ONCE UPON AN ISLE

The Story of Fishing Families on Isle Royale

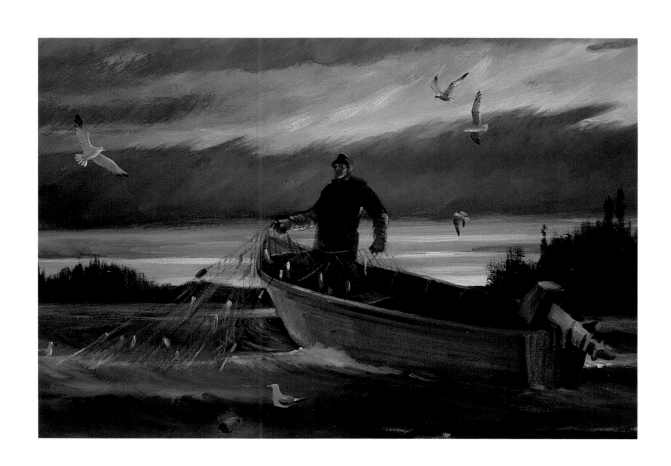

ONCE UPON AN ISLE

The Story of Fishing Families on Isle Royale

Paintings and Companion Stories by Howard Sivertson
with Afterword by Timothy Cochrane

Wisconsin Folk Museum
Mount Horeb, Wisconsin
1992

The Wisconsin Folk Museum is a non-profit educational organization
devoted to the preservation of the living folk arts and folklife traditions
of the Upper Midwest. The museum's educational publications serve to
bring the rich and diverse folk culture of the region to greater public attention.
The Folk Museum also sponsors public exhibits of folk art
and special events throughout the year.

For more information on the Folk Museum, and a free catalogue of
affordable books, prints, cards, audio cassettes, and other items, write:
Wisconsin Folk Museum
100 South 2nd Street
Mount Horeb, Wisconsin 53572
(or call toll-free 1-800-736-9189)

ISBN: 0-9624369-3-3
Library of Congress Catalogue Card #92-80729
Manufactured in the United States of America
Printed on acid-free paper
This is printing number: 10 9 8 7 6 5 4 3 2

Photographs in Introduction and Afterword are courtesy of Howard Sivertson.

Book Design: Lisa Teach-Swaziek, PeachTree Design
Editor: Philip Martin
Editorial Consultant: Janet C. Gilmore
Printer: Park Printing House, Ltd.
Color Separations: Four Lakes Colorgraphics Inc.
Typesetting: KC Graphics, Inc.
Binding: Nicholstone Book Bindery

Major support for the diverse programs of the Wisconsin Folk Museum
in 1992 came from the National Endowment for the Arts, Folk Arts Program,
and the Wisconsin Arts Board. Special thanks to those agencies for their
encouragement of our documentary and outreach efforts.

This book is dedicated to my children
Jan Sivertson
Jeffrey Sivertson
Elizabeth Sivertson

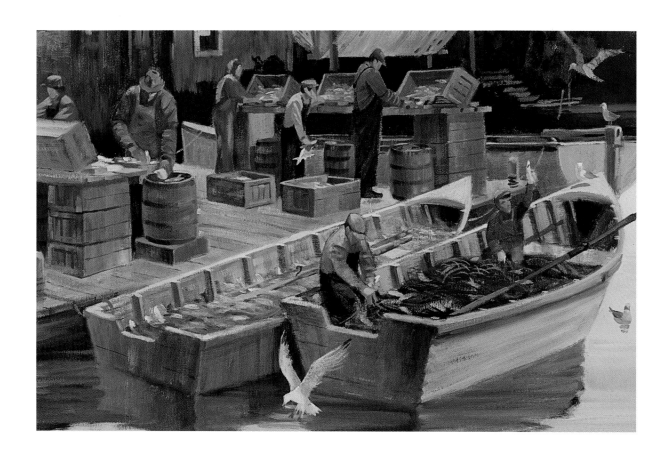

Table of Contents

Preface

Welcome to a wonderful book of Lake Superior memories —a glimpse of the human heritage of Isle Royale in the first half of the 20th century. These beautiful paintings and companion stories depict the everyday life of fishing families that lived on a unique wilderness island—then a fisherman's home, now a National Park.

To create this remarkable collection of images, Howard "Bud" Sivertson has tapped an unusual array of skills—as painter, story-teller, and ex-fisherman. With a studio in Grand Marais, Minnesota, on Lake Superior, Sivertson enjoys a widespread reputation as a painter of northwoods scenes. Working in oils and watercolors, he is known nationally for his releases of prints in series depicting the region's fur-trade history and canoe wilderness areas.

Sivertson's story-telling skills shine as well in this book. His documentary, often-dramatic narratives are steeped in a northwoods tradition that blends factual reminiscence with classic Scandinavian understatement. Wry tales of everyday life, they draw the reader into a world of island folkways, humorous incidents, and engaging characters.

Most important to the heart and soul of this book, the paintings and stories are mostly autobiographical. Howard was raised in the life he depicts, growing up in a commercial fishing family on Isle Royale in the 1930s and '40s. The traditions of the island fishing families—reflecting the beauty of their surroundings, the humor and drama of their stories, and the hardships of their work—could not have found a more caring interpreter than Howard to bring them to life.

If people think at all about commercial fishing, most probably picture much larger operations—big boats, mechanized equipment to pull nets from the sea, massive docks, giant cranes to unload, conveyor belts to move tons of fish through processing stations.

Here is a different image: small families working hard to "get by" and pay the bills. The scale is that of a work setting more familiar to many: the family farms of the Midwest. As in other traditional occupations, the small fisheries found on Isle Royale were built on knowledge and skills passed down through generations of families. All members of the family were involved, from oldest to youngest, each doing their part. Typically, the work demanded long hours that no one would voluntarily choose unless they grew up with it. And like small farmers, the fishing families of Isle Royale often lived on the edge of bankruptcy—despite their best efforts—according to the whims of foul weather, bad luck, accidents, market changes, moody creditors, and fluctuating government policies.

In many ways, the depth of the local, long-term knowledge that builds up around a traditional occupation is amazing. Isle Royale is an example of a small island with its own patterns of fishing. Work habits developed over many decades—of daily repetition, small experiments, watching what neighbors were trying, exchanging tidbits of advice, and story-telling to educate the young.

While taking place in an isolated setting, the traditions of the Isle Royale families reflect the folk knowledge found in every occupational locale in the Midwest. Throughout the region are scattered countless small, diverse, often family-run operations based on fishing, farming, trades, or other traditional work. Each small shop, farm, or fishery has its own rich world of customs, stories, and skills, tuned over generations to fit its local environment.

Seen in perspective, this Midwestern folk knowledge is a vast and valuable body of very practical information. It is also

a well-spring of human values. Perhaps most crucial to consider, in today's world these folkways and family values are often endangered. Once gone, they are irreplaceable.

In the Afterword, folklorist Timothy Cochrane takes a closer look at the folk values expressed in Sivertson's work. Like Sivertson's, Tim Cochrane's contribution reflects a unique diversity of experience. In the late 1970s, Tim was working as a Park Service ranger on Isle Royale, patrolling back-country wilderness areas. During this time, he first met Howard and some of the other local fisher folk. This led him to pursue a second career as a folklorist, focusing on the relationships of folk groups to natural environments. Periodically he returned to Isle Royale, working again from 1989 to 1991 for the Park Service as a cultural resource specialist. He collected oral histories and documented island traditions of fishing, folk architecture, narrative styles, and boat-building. He now works as a historian for the Park Service in its Alaska division.

Cochrane looks at Isle Royale fishing families as a positive example of a traditional folk group living in a wilderness area. In his thoughtful essay, he explores issues of conflict on Isle Royale between a doctrine of wilderness preservation and the values of the local folk culture. From his dozen years of commitment to both fields, he argues for a vision of wilderness that would allow folk groups to retain traditional stewardship roles.

Once Upon An Isle is a facinating portrait of a traditional culture. Wrapped in many intangibles, any folk culture is hard to document. To many of us, a photograph would be considered more "documentary" than a painting. An inventory of a fishing household would be considered more accurate than a story told to pass the time. Yet photographs and facts are often misleading. They omit more than they tell. As Howard mentioned to me, "everytime someone on the island got out a camera—we all stopped whatever we were doing, stood up, and smiled."

In a folk culture, many small things add up to a whole greater than the sum of its parts. *Once Upon An Isle* has that quality. The book is a loving tribute to a place and its people. Perhaps these intertwined paintings and stories, this unabashed love for a family's home and heritage is, in itself, one of the truest documents of what traditional culture is all about.

More than a story of an island, *Once Upon An Isle* is an insight into a way of living—based on traditions of work, family values, and a sense of place—that shows us a rarely-considered form of stewardship that combines the best of human ways with wilderness.

Philip Martin, Director
Wisconsin Folk Museum

CANADA

MINN.

GULL ISLANDS

PASSAGE ISLAND

FIVE FINGER BAY

DUNCAN BAY

TOBIN HARBOR

BELLE ISLE

CRYSTAL COVE

STAR ISLAND

McCARGOE COVE

ROCK HARBOR

TODD HARBOR

LITTLE TODD HARBOR

CHIPPEWA HARBOR

GULL ROCK

GRAND PORTAGE

FINN REEF

WRIGHTS ISLAND

HAY BAY

SISKIWIT BAY

CASTLE GARDEN

CHECKER POINT

WASHINGTON HARBOR

FISHERMANS HOME

LITTLE BOAT HARBOR

ROCK OF AGES

McCORMICK REEF

FISHERMANS REEF

LONG POINT

ISLE ROYALE

Once Upon An Isle

Introduction by Howard Sivertson

Islands have always held a fascination for people—and none more than Isle Royale in Lake Superior. Born of fire and lava and shaped by faults and flowing ice, this cluster of rocks first appeared during a glacial retreat 11,000 years ago. Seen as a single island from today's Minnesota-Ontario shore only 12 miles away, Isle Royale is actually an archipelago stretching 53 miles long and 9 miles across at its widest.

Surrounded by 200 small outer islands and countless reefs, the main island is dominated by a backbone of ridges running northeast to southwest. Steep cliffs on the north slant to beaches on the south. The island is isolated from the mainland by the largest freshwater lake in the world, an unexcelled habitat for Lake Superior's coldwater fish.

Host to over 40 inland lakes, the archipelago is further laced by countless streams and beaver ponds. Forests of spruce, fir, and cedar rim the shores while birch, aspen, pine, and maple cover the ridges. In earlier times, the forests were home to caribou, lynx, marten, and coyote. Today, moose, wolf, beaver, snowshoe hare, and fox dominate the fauna. The island waters once included giant sturgeon, along with today's siskiwit, lake trout, whitefish, Menominees, herring, Northern pike, and suckers that thrive in great numbers.

Humans have been a part of the story of the enchanting island since the last glacier retreated. Archeological evidence indicates that prehistoric Indians harvested fish from island reefs over 4,000 years ago. In more recent history, bands of Ojibway came to *Minong* ("a good place to be") to mine the copper-studded outcrops for spear points, tools, and jewelry. They also harvested the rich resources of fish, caribou, beaver, maple sugar, and berries.

In the late 1700s and early 1800s, Euro-American fur-trade endeavors also came to the island for food. Both the Northwest Fur Company and Hudson's Bay Company may have fished off Isle Royale to feed their hungry voyageurs during summer rendezvous at company posts at Grand Portage, Minnesota, and Fort William, Ontario. From 1837 to 1841, the American Fur Company maintained the first major

Lying just off the Minnesota-Ontario shore on the north-western end of Lake Superior, Isle Royale has been an alluring base for area fisher folk, attracted by its rich fishing grounds, for over 4000 years.

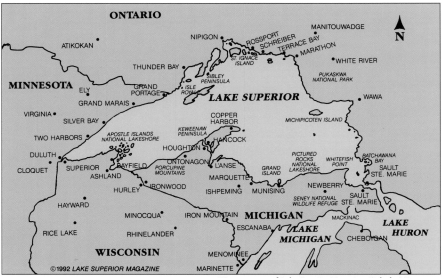

Map courtesy of *Lake Superior Magazine*, Duluth, Minnesota.

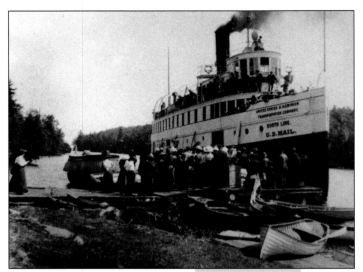

commercial fishery on Isle Royale.

Later, copper miners undertook three ventures, all unsuccessful, to separate the reluctant island from her valuable ores. Several attempts at logging failed also. In the late 1800s, sportsmen and tourists, fascinated by the island, created a demand for lodging accommodations that continues today.

Most recently, authorized in 1931, the island became one of America's wilderness National Parks. The National Park Service maintains ranger stations, research facilities, and several hundred miles of hiking trails with back-country campsites. The Rock Harbor Lodge offers overnight accommodations and a marina. Each summer, thousands of hikers, kayakers, boaters, and others visit the island. Many reach the park by excursion

The steamship America *stops at Tobin Harbor, Isle Royale, early 1900s, to deliver mail and freight.*

boats from nearby Grand Portage or the more distant port of Houghton, Michigan. Most of these visitors spend no more than a few days, if more than a few hours, enjoying the natural beauty of the rugged shoreline and inland ridges and lakes.

But one group of people came and stayed for over 100 years. Mostly of Scandinavian descent—many were immigrants from the coastal fishing villages of Norway—these families first arrived in the mid-1800s, attracted by the rich fishing grounds surrounding the island. With considerable risk and hardships, the men ventured out daily in small, open boats—one or two men to a boat—to fish with nets and long hooklines. By working long hours, the island families managed—if all went well—to pay the bills for groceries and fishing supplies bought on credit.

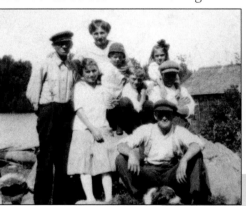

When the harbors began to freeze in November, the families returned to the mainland to wait out the depths of winter. Each year, in April, they migrated back to their island homes to start a new season.

For three or four generations, these fishing families shipped countless tons of fish, year after year, to feed the growing

populations of Midwestern towns and cities. This book tells their story—a fascinating, little-known tale of how these pioneering families lived on "the rock." With a pride in independence and hard work, they wrested a livelihood from the cold waters and raised their children in the wonderful surroundings of an island paradise.

My grandparents Severin (Sam) and Theodora (Dora) Sivertson immigrated from Egersund, Norway, and settled in Washington Harbor, on the southwest corner of Isle Royale, in 1892. They were part of the traditional fishing

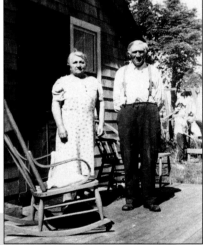

Left: My grandparents Sam and Theodora Sivertson with their children Bertha, Stanley, Arthur, and Myrtle (and two neighbor kids, with caps, on right), 1917.
Right: Sam and Dora, mid-1940s.

culture of the island until they died, Grandma in 1948, and Grandpa in 1953. Sam and Dora (or T'dora, as Sam always

called her) raised four children. Their two sons, Arthur and Stanley Sivertson, fished island waters and started the Sivertson Brothers Fishery and Grand Portage/Isle Royale Transportation Company. At the time of this writing, Stanley holds the last license to fish on Isle Royale. Sam and Dora's daughters, Bertha (Eckel) and Myrtle (Johnson), married commercial fishermen and also raised their families on the island.

My father, Arthur Sivertson, married Myrtle Bjorlin, a farmer's daughter, in 1928, introducing her to the rigors of primitive island living just a few hours after the wedding. They raised my sister Betty and me in the traditional ways of the island's fishing culture, providing a modest living in a spectacular environment.

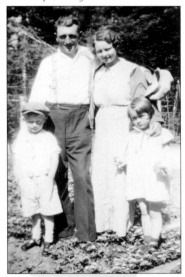

My parents, Art and Myrtle, with my sister Betty and me, ca. 1935.

Dad's last year of fishing was in 1955, after the lamprey eel and smelt invasions. These two deadly predators devastated the lake trout population. At the same time, National Park Service policy phased out the rights of fishing families to live on Isle Royale, virtually ending the island's age-old fish harvesting tradition by the 1960s.

My first trip to Isle Royale occurred just a few weeks after I was born on May 31, 1930. Every April, my parents migrated to Washington Harbor from our winter home in Duluth, Minnesota. In late November, they would then return to Duluth before freeze-up. Prior to school age I traveled each year with them. After I started school, I lived on the island during summer vacations.

Even though once I reached school age I spent more time on the mainland than on Isle Royale, I considered the island "home." Island impressions dominated my formative years and shaped my attitudes, morals, and ethics. I learned self-discipline, perseverance, independence, productivity, pride in work—and how to play—by observing and being part of a hard-working, dedicated, fun-loving community. Love, appreciation, and respect for nature came easily. Our lives and livelihoods depended on understanding and abiding by nature's laws.

There were seven of us "island brats" at Washington Harbor in the 1930s. It was a

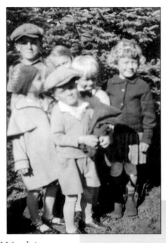

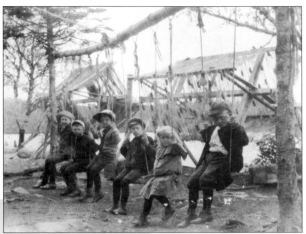

Two generations of "island brats" at play.
Left: (Clockwise from upper left): Tom Eckel, my sister Betty, me, Joanne Skadberg, Dick and Patsy Eckel, 1930s.
Right: My father Art and friends on swings at island home, ca. 1908. Note the large net reels in the background.

unique experience growing up on a wilderness island that offered the adventure and mystery of exploring woods, coves, beaches, and trout streams. We hunted moose, squirrels, rabbits, foxes, beaver, ducks, seagulls, and hawks with homemade slingshots. A fish hook, line, and a Prince Albert tobacco-can full of worms fit neatly into my back pocket. They were always handy to angle for "speckle" trout, chubs, Menominees, and sculpins in trout streams and under dock cribs.

The island was a Huck Finn paradise where we were never bored. We swam every day in the cold lake, dressed in our overalls and sweatshirts. We played hide and seek in the woods, had rowboat races, or visited the ladies on baking day.

We moved from woods to beach through fields and meadows, changing

course in unison like schools of fish or flocks of birds. We were "self-cleaning," as we wandered from mucky cedar swamps to wade in shallow bays, chasing minnows, then moved through short balsams and tall grass playing children's games. When we tired of play, we would watch the antics of the colorful and good-natured fishermen, coming and going. All this happened after chores, of course. Work always came first.

The island was a secure, happy place with endless things to do. It was small enough that I could comprehend the way it worked. The people and things that influenced my life were within sight or shouting distance. Life on the island was uncomplicated, understandable, and even controllable at times.

As I got older, more work and responsibility were expected from me. By eight years of age I helped with land chores. By age

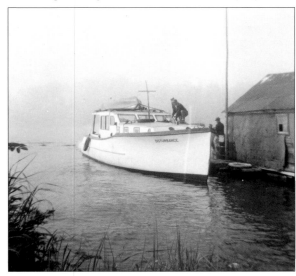

The Sivertson Brothers' Disturbance delivered mail and freight to the island from 1945-1954.

twelve, I was expected to work like a hired man and go on the lake each day, baiting hooklines and lifting nets with Dad.

At first, my dad had high hopes for me. To this point, he had fished most of the time alone in his boat, while the two hired men who worked for him, Carl and Einar Ekmark, worked a second rig from another boat.

But both my dad and I realized quickly that I was not cut out for commercial fishing. I was a "dreamer," more interested in scenery and seagulls than hard work. My lack of concentration and abilities required in the daily activities of commercial fishing made me a dangerous partner on the lake. My chronic seasickness was another cross my father had to bear. He was not disappointed when, in my late teens, I announced my intention to become an artist.

But I persevered for a time, earning enough money at commercial fishing and related activities to finance my advanced education, graduating from the Minneapolis School of Art in 1950. I continued to fish part-time for the next two years. I was about as much of a fisherman as Charles Russell was a cowboy— a thought I find encouraging.

I was married in 1952, served two

years as an illustrator for the United States Navy, then spent 25 years raising a family as a graphic artist in Duluth, Minnesota. I was divorced in the early 1970s and after the children grew up and left, I moved to a shack in the Superior National Forest to

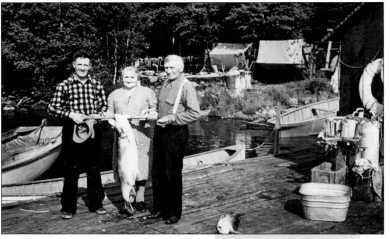

rekindle my career as a fine-arts painter, working in watercolor and oils.

Uncle Stan, with Sam and Theodora on their dock, showing off a 45-pound lake trout.

After three years in the woods, my paintings began to sell, giving me confidence to move to Grand Marais, on the Minnesota mainland near Isle Royale, where I opened an art gallery with my artist-daughter Jan. My other artist-daughter, Elizabeth, soon followed. Jan now owns the Sivertson Gallery and the three of us earn our living with art. My son Jeff, also artistically inclined, chose to become a heavy-equipment operator for St. Louis County, Minnesota.

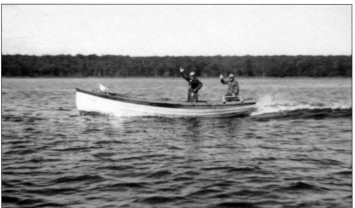

Neighbors Gust Bjorlin and Charles Parker wave as they pass by in the Skipper.

I still spend most of my summers at Isle Royale. The seasons of 1990 and 1991, my wife Janice and I worked as cultural demonstrators for the island's National Park Service at the Pete Edisen Fishery—a re-established site which interprets a typical commercial fishery of the 1930s to 1950s.

This story of the Isle Royale fishing families has never been fully documented. As tangible evidence, photos from family albums and a few rotting boats and buildings are all that is left. The old photos, however, show few details of men on the lake, women at work, or children at play. Nor do today's crumbling structures and old boat hulls explain the drama of these people's lives.

As the only survivor of the fishing culture with the training and desire to illustrate life on the island, I felt the need to document my experiences. The paintings are from childhood memories and stories

passed down from generation to generation. Family photo albums, local historical societies, and the Duluth Canal Park Marine Museum furnished some details. A number of scenes are of specific people in specific places. Other scenes are more general. In some cases I have taken liberty with composition to better tell the story.

As a narrative artist, I am trying to communicate with the most people possible. The story is most important to me. The art is the medium I chose to tell the story. Most of the oil paintings are 22" by 28" on high-quality Belgian linen canvas and should survive for many, many years.

I remember once when I was five years old, I returned to Duluth from Isle Royale to attend kindergarten at Merritt Grade School. The teacher asked the children to introduce themselves and tell what they did during the summer. When my turn came, I had difficulty expressing myself. My terms and place names describing Isle Royale made little sense to outsiders, so the teacher asked me to draw what I was talking about on the blackboard. Two hours later I had filled every board in the room with pictures of gas boats, steamships, moose, net reels, and so on. The experience made me aware of my unique upbringing on Isle Royale and, stimulating my interest in art, changed my life forever.

I am still painting those island pictures.

I have completed many and have more I hope to paint. Special credit is due to Loren and Arlene Swanson, art collectors from the Twin Cities. They made this long-imagined book possible by offering several years ago to commission over 35 of these paintings of island life. Thanks also to the Wisconsin Folk Museum for its enthusiastic support, and especially to Dr. Timothy Cochrane and

Howard Sivertson in Grand Marais studio, 1992.

Dr. Bill Raff, whose many years of interest in Isle Royale traditions and personal friendships have encouraged me greatly. Much kind support has helped me achieve my dream: to tell the story of the fishermen and their families who gathered the rich harvests of life on Isle Royale.

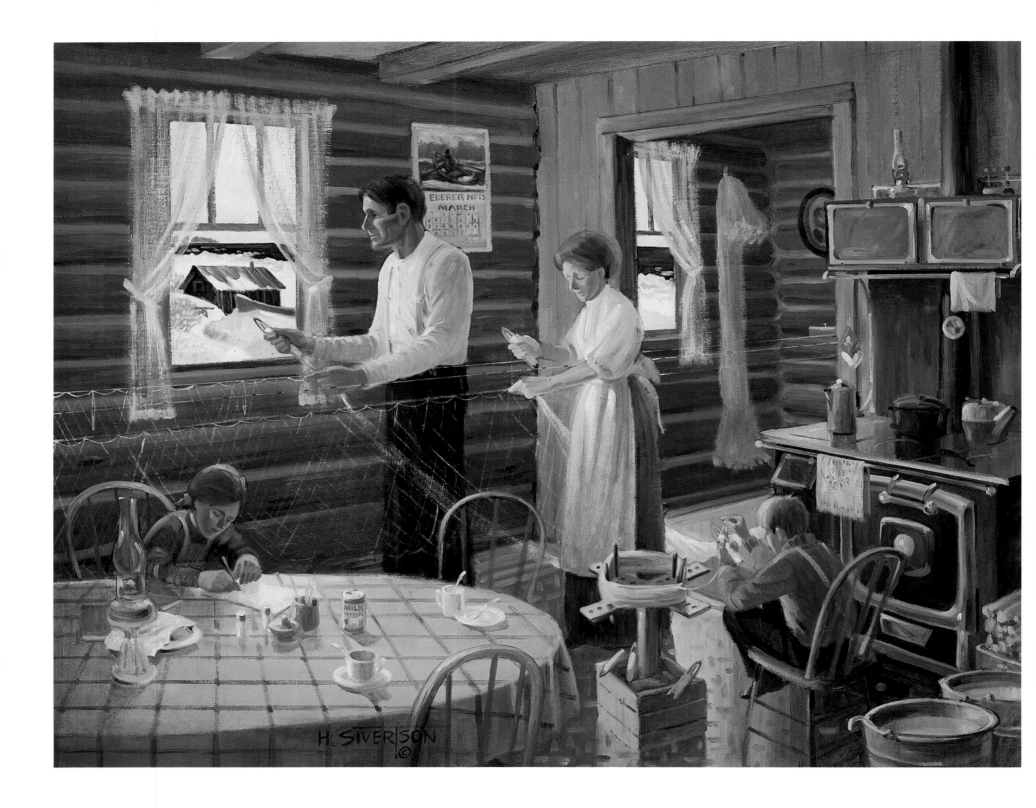

Winter on the North Shore

Midwinter found the Isle Royale families living on Minnesota's North Shore—waiting for spring thaw to clear the ice from Lake Superior harbors. Often these winter quarters were quite small, as the islanders lived here for only a few months each year. My parents rented a place each winter in the city of Duluth. My grandparents Sam and Dora stayed with relatives in the little town of Lutsen, Minnesota. Not until "ice out" in April could the island families return to their beloved Isle Royale homes.

The commercial fishing season on Isle Royale lasted from April until late November. Each year, in November, the island families returned with most of their gear and household possessions to the Minnesota shore. From mainland harbors, the men could continue to fish for herring until "freeze up" in February. Some found work in northern Minnesota logging camps, while others took odd jobs or just hunkered down to wait out the winter.

In the early 1900s, as seen in this picture, children of Isle Royale families had to complete a whole nine months of schooling during their few months on the mainland. There were no schools on the island. The children spent a lot of time each winter studying. Otherwise, they were kept busy with chores, including helping with the annual "rigging up."

Rigging-up involved the entire family. Bulk netting, "miter" cord, and seaming twine were ordered from netting companies. Old nets were mended, and new nets were "seamed" or "hung" right in the home.

Through the longest section of the house, a straight pathway was cleared of furniture. Down the middle of the alley, the fisherman strung a measuring line with ink marks to indicate where knots should be tied. On either side, he strung parallel lines of miter cord, resembling two clotheslines.

Bulk netting was laid on the floor the length of the pathway. Each edge of the netting had to be lifted and "seamed," or sewed—to either the cork-line or the lead-line—using wooden needles with twine.

Two people were usually required to seam a net. Often the wife of a married fisherman was an excellent seamer with fingers more nimble than his. Both walked backwards, one along each line, swiftly tying knots in competition with each other. A typical net was about 300 feet long, depending on the exact needs of the fisherman, and took several hours to finish. Children helped by filling six-inch wooden needles with seaming twine pulled from a "hank" on a "spin jack."

Soon the family in this painting will receive word of the coming steamship's first trip of the year to Isle Royale. Everything needed on the island—clothes, tables and chairs, nets, skiff, and supplies—will be packed for the trip. Most families could not afford to purchase two of everything, so they took it all with them. Even the cast-iron cookstove will be carried out and loaded on the steamer. For the Isle Royale family, another season "on the rock" was ready to begin.

In my childhood, crossing to Isle Royale also was a journey back into time. From the 1930s well into the '50s, we left the modern, luxurious living of the mainland and arrived on the island to an old-fashioned lifestyle of a past century. For me, it meant leaving a world of electric lights, telephones, bicycles, and fast automobiles to return each year to kerosene lamps, scrub-boards, water buckets, and 10-m.p.h. boats. Time stood relatively still on Isle Royale.

Spring Arrival

While some families took the first April trip to the island together, most often the men traveled first with the women and youngest children following a week or two later. When children reached school age, they were "boarded out" to friends or relatives and remained on the mainland to finish the school season before joining their family on Isle Royale.

Especially in the early 1900s, it was difficult to predict when in April the freight boat would arrive to take you aboard. Before the days of good roads, telephones, and radio, there was very little advance warning. Mail was delivered sporadically up and down the North Shore by dog team.

Likewise, conditions at the island were unknown. The ice might have cleared from the main lake, but no one knew whether there was still ice in the various harbors around Isle Royale. Many times the fishermen arrived at the island to find it still "socked in" with ice. They then had to unload on ice fields, a mile or two out from their homes and docks.

The painting shows the steamer *Winyah* unloading fishermen's skiffs and supplies on the ice outside of Washington Harbor in the 1930s. With several other families, my family lived on a small island, Singer Island, within Washington Harbor. In all, about a dozen boats operated from this well-sheltered inlet on the south-west corner of Isle Royale, closest to the Minnesota mainland.

To cross the frozen bay, each skiff was loaded with supplies and towed over the ice to the dock and fish house. Everyone pitched in and helped each other until the job was done.

Crossing the unpredictable waters between the mainland and Isle Royale in early spring has always been chancy, causing anxiety in even the most adventuresome. With little warning, the weather could turn instantly from spring breezes to blizzard conditions.

The more familiar people of a culture were with the lake's terrible moods, the more respect and fear they had for it. Woodland Indians, before crossing in birchbark canoes, calmed their nerves by propitiating their lake gods with gifts and ceremony. In the Ojibway language, they called the island "Minong," which means "a good place to be." It was named, I'm sure, upon arriving safely after a particularly stormy crossing.

The Scandinavian fishermen also knew the sudden vicious storms and confusing fog of Lake Superior and treated her with respect and fear. At times, before a crossing in small open boats, some might have unceremoniously propitiated their own "God of Bravado" with a dram or two of brandy. To some men, a rough crossing was time for a silent prayer, while others relied on the belief that "there's some things a man has to do by himself."

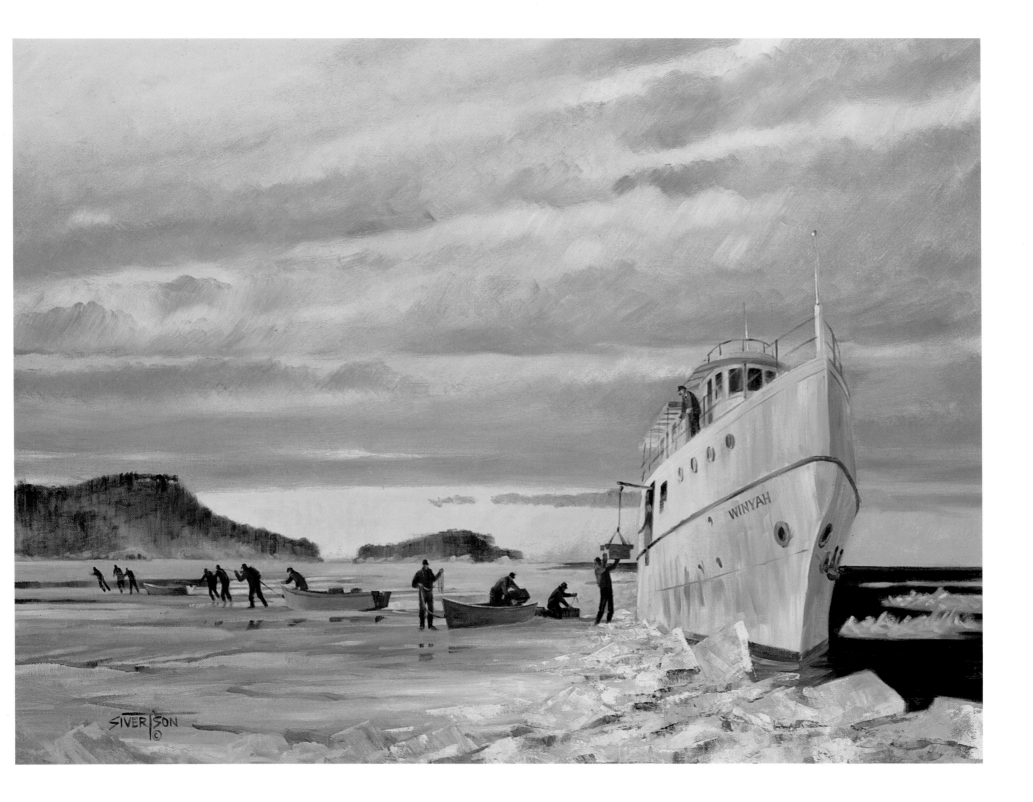

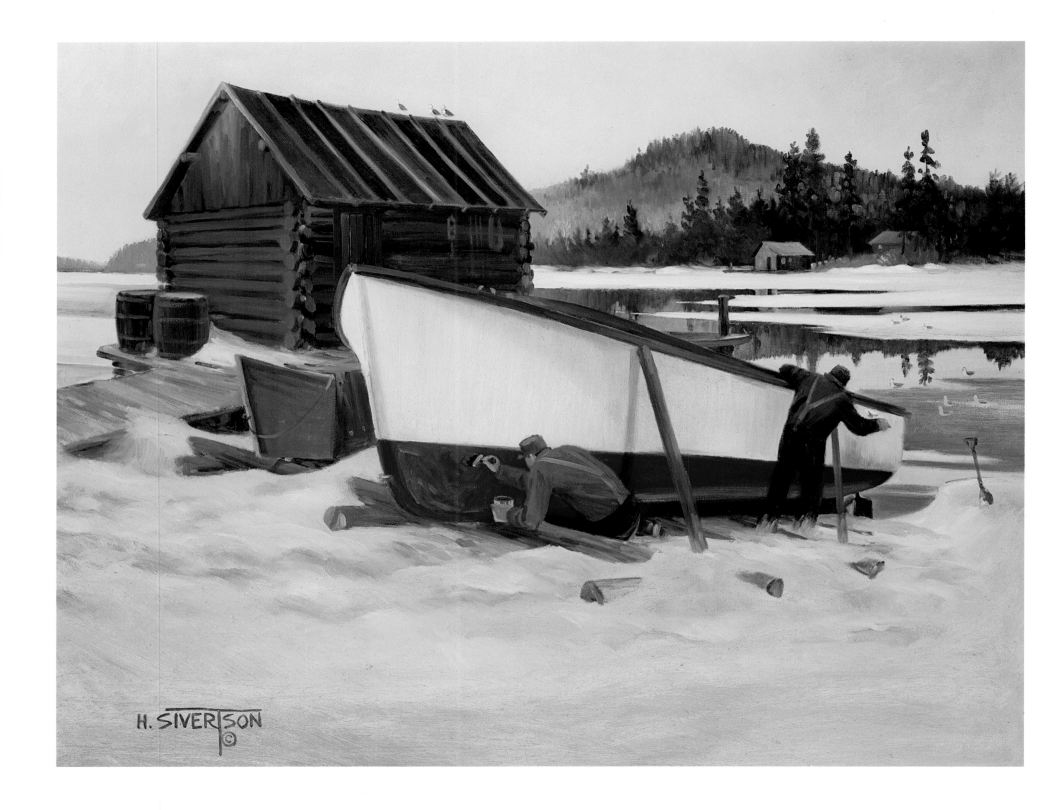

H. SIVERTSON

Painting the Gas Boat

The gas boat was painted immediately upon arrival. Even before unpacking, snow was cleared away, and the hull was scraped, painted, and launched to "soak up." Spring fishing was highly competitive. Favorite fishing grounds were claimed by the first fisherman to set out hooklines in an area. From then on, for the rest of the season, that area was his.

As soon as harbors were clear of ice, the fishermen set "bait nets" to catch enough small herring to bait their hooklines. They used the herring as bait to catch their main market fish—lake trout—on hooklines set farther out in the deep waters of the lake.

The "gas boat," about 24 to 26 feet long, was descended from the older Mackinaw two-masted sailing schooner, but was now powered by a gasoline engine. Thus the fishermen called it a "gas boat" as opposed to a sail boat. The gas boat was used in the spring and early summer to fish hooklines, and in the fall to set nets when the fish moved onto their shallow spawning grounds.

Behind the gas boat in the painting, you can see the prow of the herring skiff. This type of skiff was modeled after the dory used in Atlantic waters. Originally a "double ender" (pointed at both ends), with a flat rocker bottom, the dory was modified to a more box-like shape. To accommodate an outboard motor, a square transom replaced the pointed stern. The skiff was used

mostly to fish herring nets in sheltered bays and harbors in the spring.

While the planks in the wooden-hulled gas boat were swelling tight by absorbing water, the fishermen got ready, setting herring nets and rigging anchor and buoy lines to be used with the hooklines. If conditions were right, they would have their first "stretch" of hooklines set in not more than a day or two after arrival at the island.

Many years, on arriving at his dock, my father also had to shovel a path through hip-deep snow from the fish house to his living house, 200 yards away. He had to cut wood, build a fire, eat something, and get a few hours sleep before rising at 3:30 a.m. to start his second day on the island.

Spring fishing was hazardous and uncomfortable. While folks on the mainland were watching tulips grow, the fishermen on Isle Royale were plagued with blizzards, cold water, high winds, and thin "night-ice" forming on the harbor. They went to work in the dark and came home in the dark to cold, empty houses.

But shortly the wives and children would arrive. Houses would become cheery and take on a new warmth. Meals would be better, clothes cleaner, beds warmer, and the sunshine brighter.

The *Winyah*

She was a spooky ship to me. Even her greatest claim to fame did not change my feelings toward her. She was the beautiful ocean-going yacht of Andrew Carnegie, built and christened the *Dungeness* in 1894. In the late 1920s, H. Christiansen and Sons Fish Company bought her to take over duties performed by a previous vessel, the *America*. The Christiansens stripped her of yacht finery and added another deck with pilot-house and state-rooms, making her more functional at the expense of aesthetics. Her name had been changed to the *Winyah* in 1900 and the sound of it still makes me a little queasy.

My mother, sister, and I had to board the too-narrow, top-heavy, steam-belching monster each spring for the trip to join my father who was already fishing at Washington Harbor on Isle Royale. The sound of heavy seas, driven by cold northeast winds against the breakwall at Grand Marais Harbor, announced a typically rough six-hour ride to come.

We boarded at midnight. With great reluctance, my five-year-old body trudged up the gangplank. The dim red lights created grotesque forms and eerie shadows as deck hands loaded cargo. The wheezing and clanging noises of steam hoist and engines, rising out of the bowels of the dark monster as it swayed sickeningly by the dock, stimulated my young, over-active imagination.

A huge shape, barely discernible in the shadows, gruffly welcomed us aboard with his usual evil laugh as he handed me my very own "puke bucket" and directed us to the long, dimly-lit ladder to our cabin. Five years old, I was taking my fifth trip to the island with Captain Martin Christiansen, who loved to tease me about my seasickness. I'd thrown up mother's milk on my first trip when just a few weeks old.

As Pavlov's dog salivated at the sound of his dinner bell, I immediately felt queasy at the sight of my bucket. With rope-tied suitcase in one hand and bucket in the other, I climbed the stairs to the hot, steamy stateroom, where I'd been known to throw up before leaving the harbor.

A loud hair-raising blast of her steam whistle, the rumble of accelerating engine, and the shudder of churning propeller announced our departure into the northeast seas in black of night. Hopefully I'd sleep the next six hours before joining Dad, relatives, and friends at Washington Harbor, where my misery would turn to joy again.

I tried to flatter the *Winyah* in the painting. I cleaned up her hull and gave her an idyllic setting—leaving Isle Royale's Rock Harbor through Middle Island passage, past the Rock Harbor Lighthouse. I'm sure she must have had serene trips even though I never experienced one. She retired in 1943, and was finally scrapped in the '50s. I'd like to have helped.

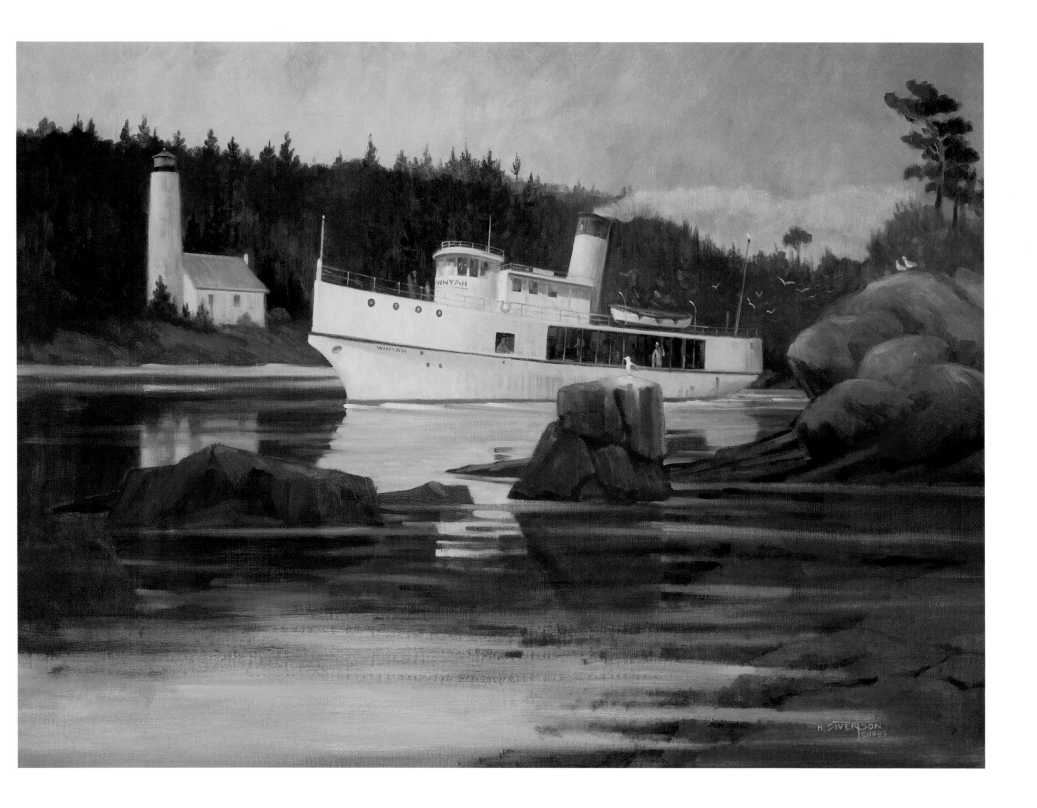

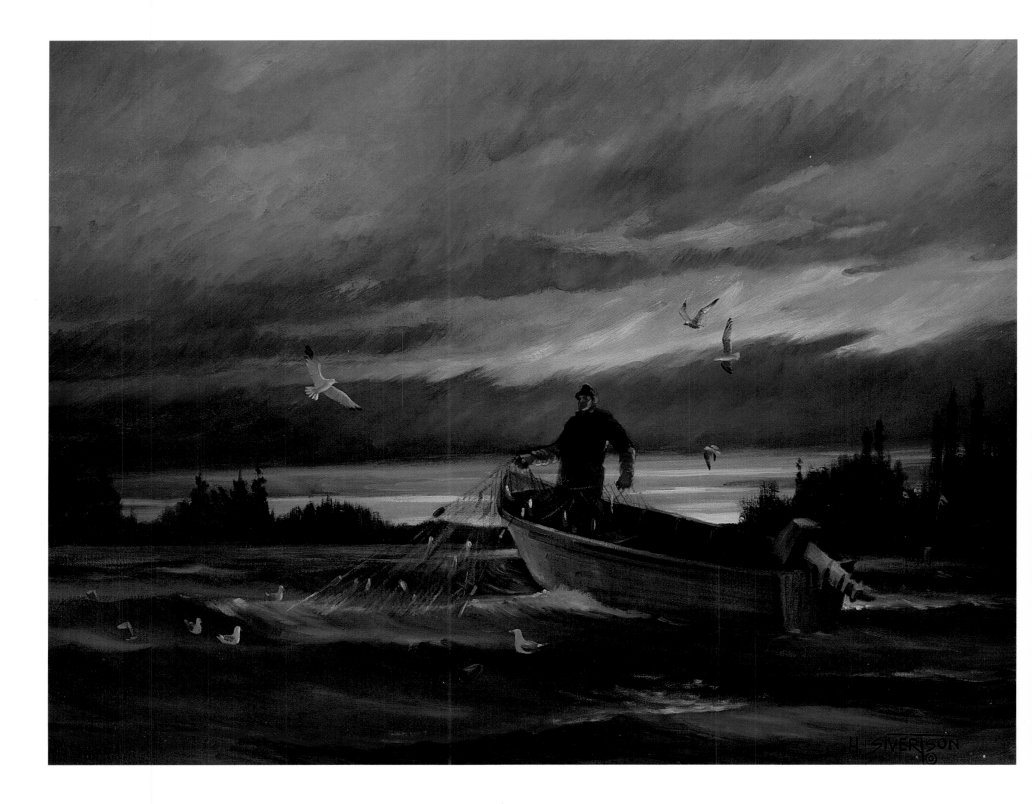

Picking Bait Nets

My mother got up first every morning at 3:30 a.m. She built a wood fire, lit the lamps, roused my father, and helped dress him in wool socks, an extra pair of long underwear, shirt, and pants. She helped guide him into his rubber knee-boots that had dried by the stove overnight, then steered him to the door and sent him into the cold dark morning to pick bait nets.

In the days before outboard motors, Dad would row his 18-foot skiff several miles to his herring nets. The exercise kept him warm as his skiff slid along through the thin "night ice," making a tinkling sound like fragile glass breaking under the hull. With the advent of the outboard motor, the early-morning run to the net was faster but much colder.

He arrived at his nets as the first crack of light lit the clouds overhead. Hopefully he would get the 400 to 500 herring necessary to bait his hooklines. His strong hands, swollen from the cold water, looked deceivingly clumsy but nimbly squeezed and twisted each herring from the entangling meshes at a rate of about one fish every two seconds.

After picking the bait net he hurried home to his fish house to "cut bait" and "bait on."

For use as bait, each herring was cut in half diagonally from the back of the head to the anal fins. Only the back-half was used, the front-half thrown away. Dad took the end of a five-foot string, tied to a hook, and pushed it along the backbone from front to back with a stiff notched wire. When the free end of the string came out the anus, it was pulled through until the hook snugged up against the flesh, the barb resting along the back. When tied to the weighted hookline "snell," each halved herring would bob upside down in water 150 to 200 feet deep.

Dad then stacked the herring neatly in the bait box with the strings hanging untangled on the outside. He loaded the box into the gas boat—on the engine box for handy accessibility—then covered it so the seagulls didn't eat the herring while he went to the house for breakfast and his lunch pail. By 6:30 a.m., he was in the gas boat on his way to bait his hooklines.

Later that evening he made one more trip to his bait nets, to pick off any fish caught during the day and clean the meshes of accumulated dirt. The bulk of the fish, however, were found in the morning, caught in the nets at night when visibility was poor and fish could not see the twine.

Baiting Hooklines

In the spring, lake trout ranged far out in the open lake. The lean Mackinaw lake trout swam 100 to 200 feet below the surface in deep water. Hooklines were the ideal fishing gear for this time of year, able to reach the fish at the depth they were swimming.

Each hookline consisted of a main line, 1,600 feet long, suspended by corks about 20 feet under and parallel to the surface of the lake. Each end was anchored and marked with a buoy. From the main line, a "snell" or bait line was attached every 40 feet, stretching downwards about 150 to 200 feet to a baited hook.

Most fishermen worked in pairs. One man stood on the stern seat, pulling on the long main line, steering with tiller between his knees. The other man pulled up each 150- to 200-foot snell, playing and gaffing the fish or just changing baits. The fellow pulling up the snell usually had his hands moving at a blurring pace. He had 200 feet to pull—compared to his partner's 40 feet of horizontal line—and they were supposed to come out even.

Hookline fishing was exciting but hard work. Each fish had to be "played" then "landed" almost like sport fishing. The man pulling the main line could feel the fish fighting hundreds of feet away. His partner had to pull in or give slack to tire a large fish out before it could be brought to the boat and gaffed. Any miscue meant a broken line, a lost fish, and lost income. A 50-pound lake trout would cause a lot of excitement and take a while to land. During eight to ten hours of "baiting the hooks" each day, the men averaged 20 to 30 fish, typically about 10 pounds each.

Hookline fishing meant long hours for three months straight without a day off. The day started at 3:30 each morning picking bait nets, then they went out to check their hooklines. After hours on the open waters, the men arrived home from the "hooks" about 4:00 in the afternoon to process the fish until dinner.

After dinner, the fishermen did their "shore work"—maintaining rigging and boats and motors. Just before dark, they checked their bait nets again. They finally got to bed by 10:00. The men lived, it seemed, on adrenaline, pumped by the excitement of the adventure and the anticipation of the catch.

Most fishermen set three "stretches." Each stretch consisted of eight to ten individual hooklines, tied together to make a horizontal line about five miles long. They checked and baited one every three days in rotation, in all kinds of weather, except for rare days when it was too "rough" for men or boats.

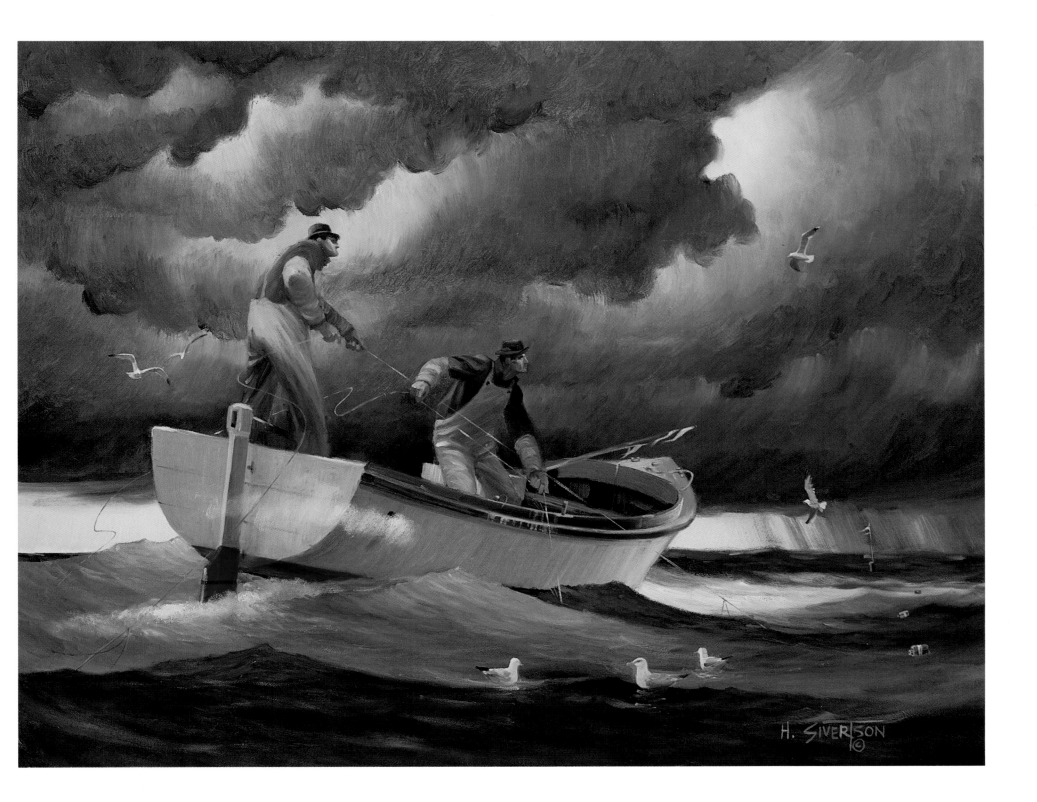

H. Sivertson

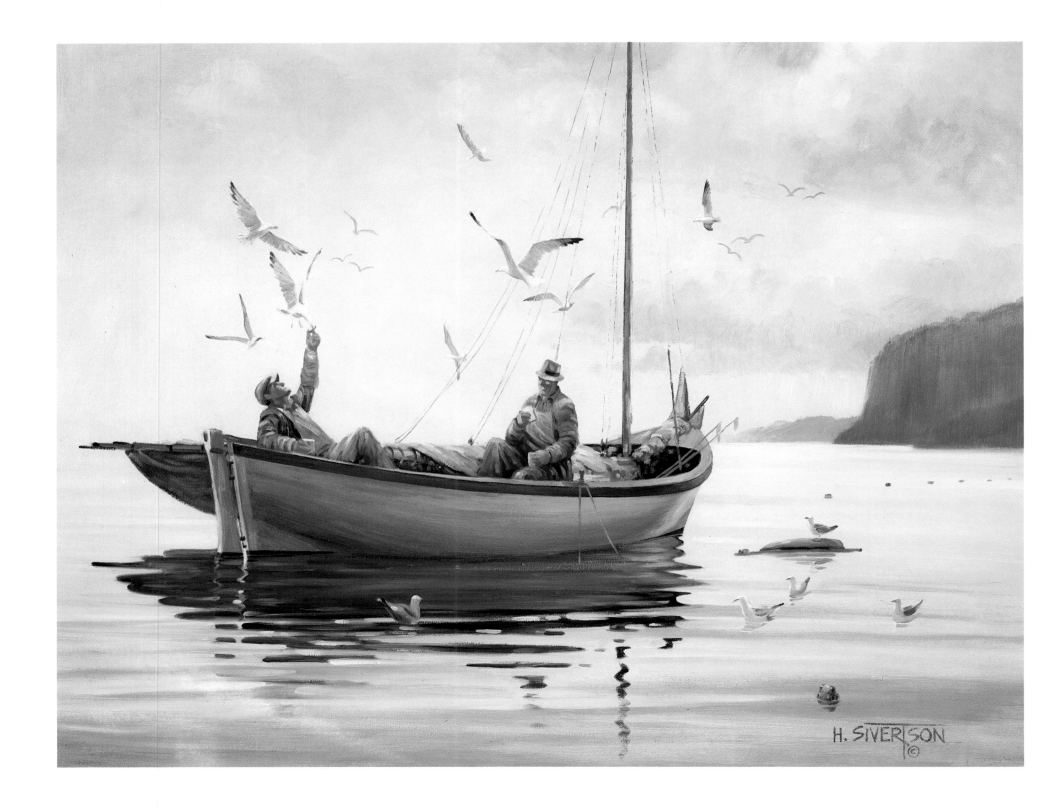

H. Sivertson©

Lunch Break on the Hooklines

Lake Superior is one of the most dangerous bodies of water in the world. The jagged rocks, hidden reefs, and fog-shrouded islands compound the danger of navigating around Isle Royale. Since the mid-1800s, commercial fishermen required a boat that could withstand the lake's fury, move among the reefs, and provide a relatively stable work platform.

The 20- to 30-foot Mackinaw sailing schooner was the boat used by most fishermen on the island from the 1850s to early 1900s. It had a spacious working area and handled huge seas like a duck. There were various styles of Mackinaws, including lap-strake, carvel-planked, and strip-built models. Most were double-ended—pointed in bow and stern—and had removable masts and centerboards. The pointed stern made her a good surf boat, and the removable centerboard allowed her to maneuver in shallow water. In the early 1900s, the hull was modified to accept the gasoline inboard engine, and from then on the boats became known as "gas boats."

The primary drawback to the otherwise perfect Mackinaw was her dependence on the wind. Many hours were spent in tedious tacking against head winds or laborious rowing in dead calm. Children developed strong arms and backs from wielding heavy ten-foot oars, rowing the sluggish hulls back from the fishing grounds while Dad sat steering in the stern, smoking his favorite pipe.

The painting illustrates having a rare leisurely lunch while baiting the hooklines in dead-calm weather. Usually the pace was more frantic, as men fought to keep their footings on the slippery deck while pulling lines, dodging hooks, untangling snarls, gaffing fish, and trying to control a boat tossed about by heavy seas.

Here, they've tied the boat to a buoy and relaxed, enjoying the unusually warm and windless day. For some fishermen, it was a tradition to feed the seagulls the last corner of each sandwich, coaxing them to eat from their hands. Seagulls were the fishermen's constant companions. The gulls depended on fishermen for food like fish entrails, and the fishermen depended on the scavenger gulls to clean up the environment.

One fisherman, Pete Edisen, was noted for training gulls to sit and ride on his hat, rewarding them with tid-bits. When asked if he ever got "messed on," Pete said, "If you want good friends you have to take some of that." That isn't the exact quote, however.

If the wind doesn't blow soon, the men in the painting will have to row their boat ten to fifteen miles home and will probably be late for supper.

The Fish House

When the fishermen came home from the lake in late afternoon, the fish house became the center of activity. Dad and the hired men worked to dress, weigh, and pack 100 pounds of trout to a box. Large blocks of ice were retrieved from the ice house, and a young apprentice like me helped chop the ice and shovel it over the boxed fish. After a cover was nailed on, the box was tagged for shipping to wholesale fish companies in Duluth.

Grandma was there to select trout for supper, and she wanted to go through every one to be sure she got the best. Her selection and instructions to the menfolk as to how she wanted it prepared depended on whether she was going to bake, fry, boil, or make fish cakes.

Grandpa took up his position on the barrel. Now retired from active fishing, he wanted to relive the day vicariously. Intently, in his Norwegian accent, he questioned the men. "How hard vas the vind blowing?" "How deep vas the fish—at 20 fathoms or 200?" "Vere did you get the most—on the inside or outside ends?" And he ended with, "And how come Tom Eckel (on the next dock) got more fish than you did?"

Children were allowed on the dock during that time. We baited small hooks with bits of trout heart and fished for speckle trout, menominees, chubs, suckers, and sculpins in holes cut in the fish-house floor. Isle Royale fish houses were built over the water on "cribs"—log boxes filled with rocks and sunk in place. The cribs were great habitat for all kinds of fish, creating fun and excitement for us youngsters.

Summer people stopped in to chat or buy a fish for their table if they were unsuccessful in their day's angling.

It was a nice time of day. The fishermen were happy to be home safe from the lake with several hundred pounds of fish for shipment. Besides the security in dollars that the catch represented, the fishermen took pride in hard work and a job well done. They had harvested enough delicious, healthy food to feed 500 to 600 people that day.

They could now slip off their rubber boots, go to the house for a hot meal, then return to shore work until dark.

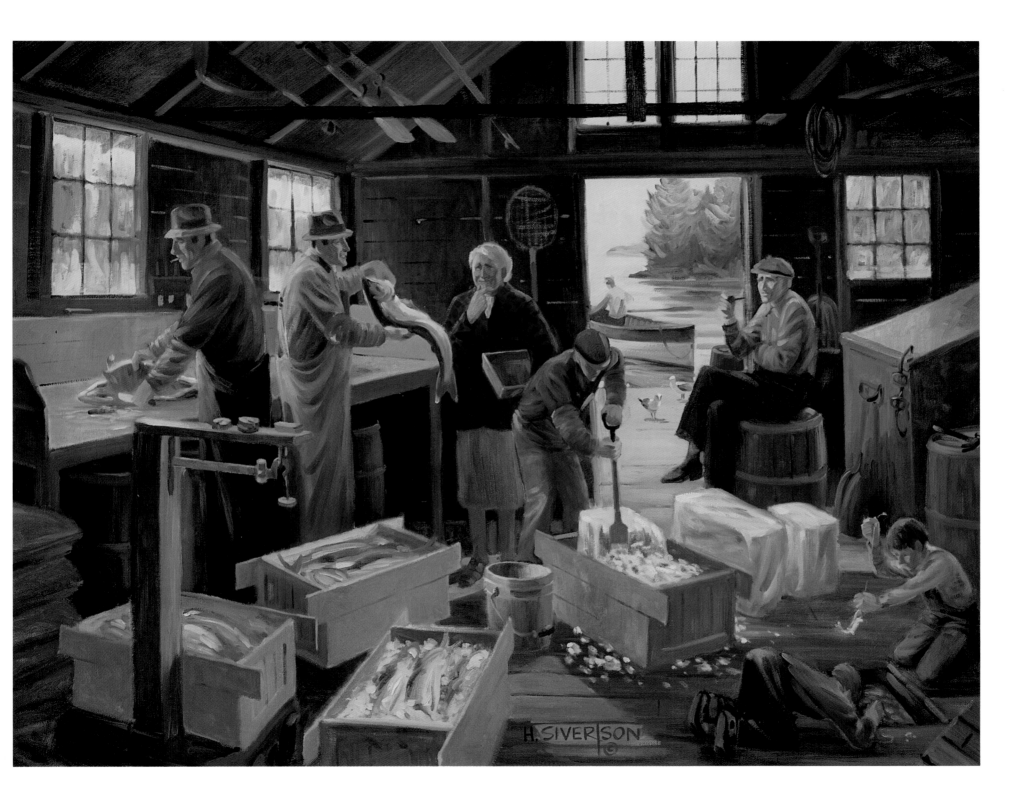

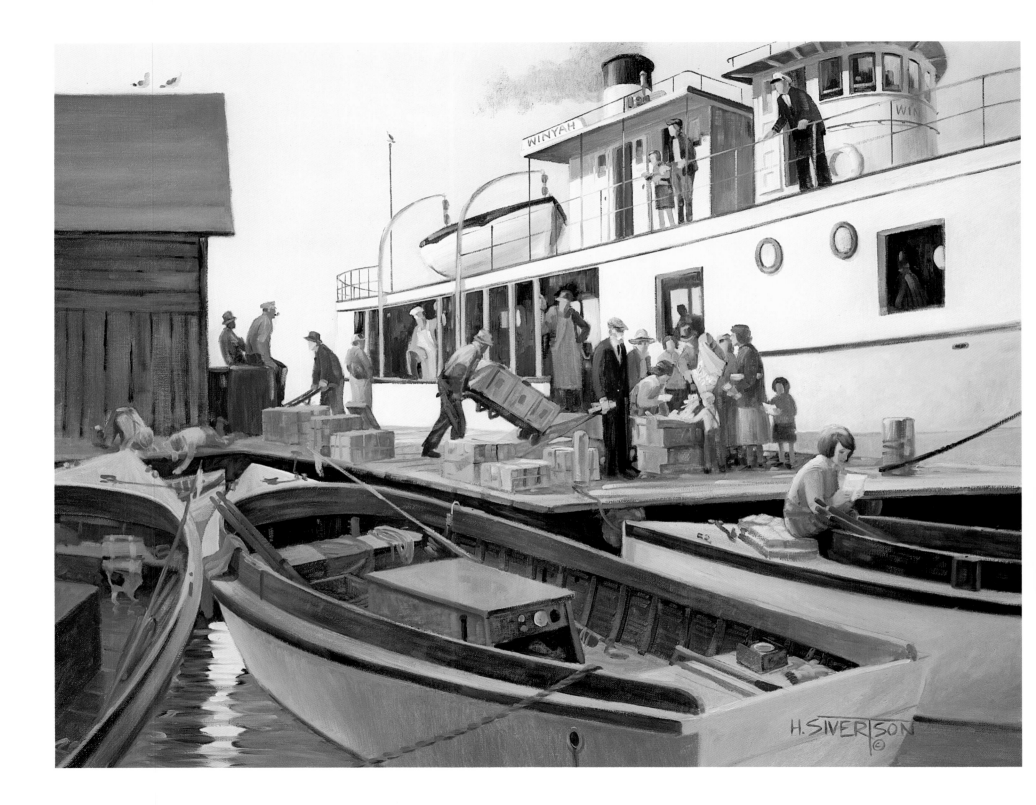

Boat Day

W hat does your Grandpa do?" "He sits in a chair and smokes his pipe." It was the same question hurled at me by Captain Martin Christiansen from the upper deck of the steamer *Winyah*, every Boat Day. The answer was always the same from Sam Sivertson's four-year-old grandson. Everyone waited for the exchange, which became almost a greeting, and laughed just as hard each time I gave my reply... at my grandfather's expense, of course.

Boat Day was exciting. On the island, traditional boat-day celebration occurred when the deep-draft steamships arrived in the large harbors. For Washington Harbor, the boat came every Wednesday and Sunday. On Sunday's Boat Day, we all had to take baths. Mothers gussied up for the big event, and even the fisher-men put on clean clothes.

The *Winyah* blew her loud steam-whistle to announce her arrival when she was still two miles away. From the surrounding small docks and islands, gas boats appeared, loaded with fish and family, all heading to Booth's Dock where the steamship would tie up to drop off mail and supplies and pick up fish.

For us youngsters, we got a chance to see kids from other islands that we ordinarily didn't get to play with. We got together to pick berries and to fish under the huge Booth Dock fish house, famous for giant speckle-trout. Women talked about pies, which berries were ripe, and everything else while sorting out the mail. The fishermen loaded their fish on the ship and exchanged lies about how many fish they were catching.

All around the edge of Isle Royale, this scene was repeated as the steamship moved from harbor to harbor. Boat Day was the only chance for many of these fishing families, isolated from the mainland and from other harbors and coves, to connect with each other and with civilization.

Owned by the fish companies in Duluth, the large mail-and-freight steamers ran scheduled routes from Duluth along Minnesota's North Shore to Ontario, circling Isle Royale in the process. Booth Fisheries ran the *Hiram Dickson* from 1888 until 1902, then the *America* from 1903 to 1928. Christiansen Fisheries operated the *Winyah* from 1930 to '43.

Although Boat Day was a great affair, it usually lasted only 30 minutes or so, then the boat pulled out and headed for its next stop.

Perilous Exchange

One hundred and twenty pounds, box and all," came the voice by the scale inside the rolling ship. The fish were hoisted from the wave-tossed skiff with a series of booms and pulleys powered by a steam winch.

Two men on board guided the box aboard and carried it to the scale to weigh and record the freight. After the fish were loaded, then mail, groceries, and supplies such as 54-gallon barrels of gasoline were transferred into the tossing skiff.

Loading at sea was perilous work even on the rare calm days when ship and skiff laid quietly together. If dropped accidentally, a barrel of gasoline would go straight through the bottom of the little skiff without slowing down.

Stormy weather made the exchange at sea very dangerous, but it had to be done. For fishermen living in remote coves too small or shallow to allow steamers to enter, the exchange of freight and mail had to take place on the open lake, exposed to wind and waves. The fish had to get to market while fresh—they would spoil if they didn't get loaded on this trip. Seldom was it too stormy to risk loading at sea.

As the *Hiram Dickson*, *America*, or *Winyah* circled the island, each followed a detailed schedule of solitary rendezvous points. The steamship would approach the rendezvous area, heading slowly into the wind and sea, holding a steady course and speed. The skiff then maneuvered alongside, matching the same course and speed. A line was secured from the bow of the skiff to a stanchion on the ship, holding the skiff in position under the hoist.

While one fisherman fended the skiff off with an oar or boat hook, the other hooked ropes from the hoist over the box handles, and 100 pounds of fish plus ice and box were hoisted aboard. Various kinds of rigging were used depending on the object loaded.

Scenes like this one repeated themselves hundreds of times, not only around Isle Royale but also all along the North Shore mainland, during the steamer's round trip from Duluth north to Canada and Isle Royale. The perilous exchanges were made in all kinds of weather, night and day, until a decline in commercial fishing and tourism during the war years put an end to steamship service in 1943.

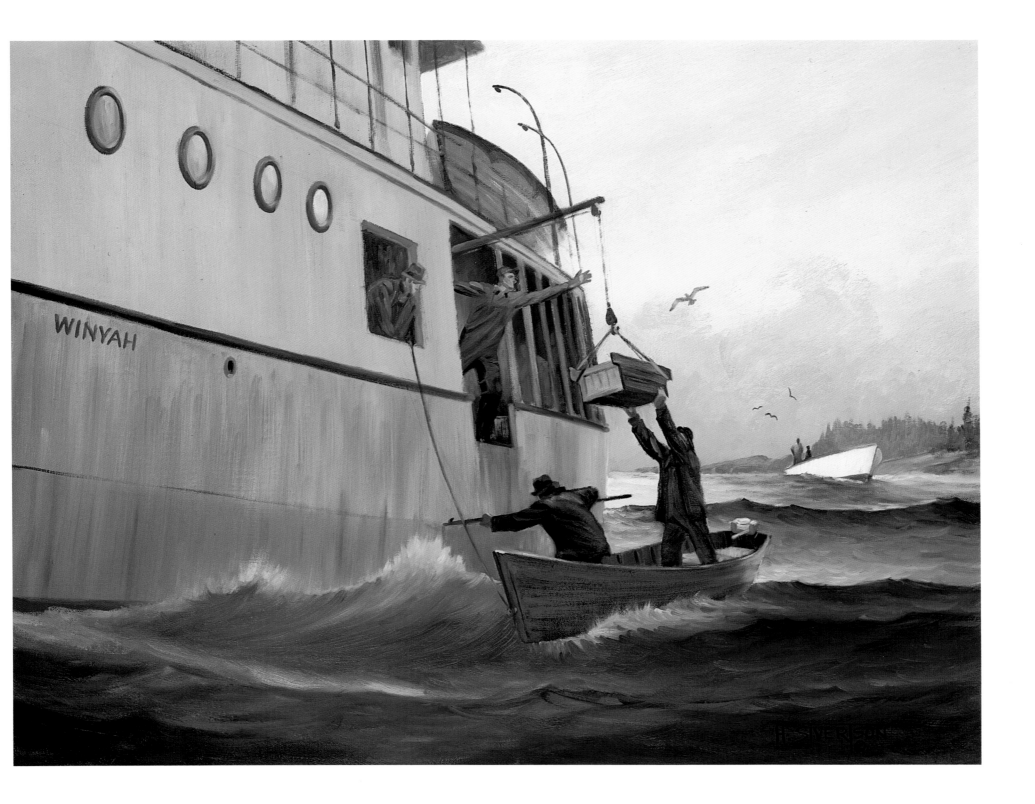

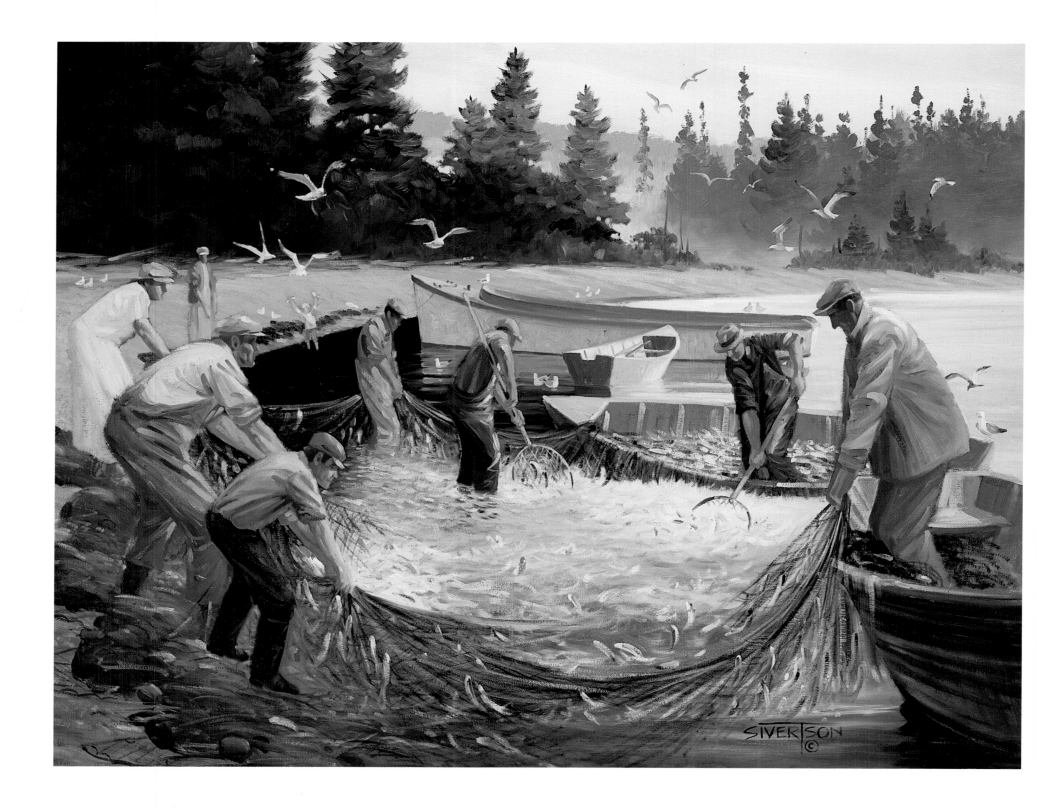

Seining

Herring in Grace Harbor!" The news traveled fast! We all dropped whatever we were doing, rounded up the other families, hauled down the seine, loaded the skiffs, and headed for Grace Harbor. Other boats joined the procession in the quest for excitement and wealth. Yes, this time we'd all get rich for sure!

When large schools of herring were sighted in harbors with gravel bottoms and beaches, the inviting call went out to anyone in the community who wished to join in the work and share in the profit. Most everyone came. Men, women, and children all took part in the "herring round-up." Gas boats and skiffs rushed to the harbor. A 900-foot-long tarred net called a seine was set in a semi-circle around the school of herring a couple hundred yards from shore. The net was slowly towed towards shore by a gas boat on each end.

Once the gas boats reached shore, the ends of the net were pulled in by hand with many people pulling on each end. After a lot of grunting, groaning, and excited yelling, the "pocket" of the net holding tons of herring came to the beach. Fishermen in skiffs surrounded the pocket while others jumped into the churning mass of jumping, squirming fish and scooped the silvery herring into the skiffs.

It was a festive atmosphere as everyone joined in the fun. Soon the skiffs were loaded, and tired, hot, sweaty folks grinned from ear to ear while they wiped their brows and congratulated each other. For a fisherman, it was a wonderful feeling having that many fish around you!

However, this was no time to rest. It was usually midsummer, the weather fair with temperature in the mid-70s. This was hot by Isle Royale standards, and too hot for the tons of fish still wiggling in the skiffs. The herring all had to be processed immediately to prevent spoilage.

The seine was gathered up. Gas boats hooked on to the loaded skiffs and towed them to the fish house and dock, where dressing and salting stations were set up. Barrels were hauled out of storage and food gathered, and fifteen to twenty people prepared for a long night of work.

Many hours would pass before everyone could return home to get a few hours sleep, then pick up whatever work had been hastily set down when they'd first heard the exciting cry, "Herring in Grace Harbor!"

Salting Down the Catch

The festive atmosphere began to wane after the seining was over. The prospect of staying up all night, processing tons of herring to keep them from spoiling, had a sobering influence on men, women, and children. The excitement was over. The real work was about to begin.

The skiffs full of herring were towed to the dock and tied up. The best "backsplitters" knew who they were and improvised their work stations on the dock using fish boxes, planks, and kegs as props. The "salters" did likewise in close proximity to the backsplitters. No one was in charge but everyone took places in the production line where needed. Once the backsplitters and salters were operational, others kept supply lines going. They scooped fish, furnished salt, sharpened knives, hauled and "headed up" kegs, and made coffee and sandwiches. After sunset, lanterns were rigged over the work area.

Scoopers supplied herring to the backsplitters, who then cut each head off with a deft knife-stroke. Another stroke split the fish length-wise along the backbone, and the return stroke scraped out the entrails. The "butterflied" fish were washed and passed to the salters, who dipped each fish in rock salt and packed them neatly in wooden kegs, to be headed up with covers when full. Because of the scarcity, cost, and inconvenience of ice, a large quantity of fish like this had to be "salted down" instead of packed in ice.

The sun set on high-spirited, energetic, hard-working people, still a little giddy about earning a good profit on the catch.

As night wore on, the laughter, good humor, and high spirits turned to silence, then mumbling and moaning. The sun rose on a semi-paralyzed, stumbling, fumbling group of run-down robots. After the last keg of salt herring was headed up, dressing knives were pried from cramped fingers, and rubber clothes were painfully removed. Tired, tortured, and spiritless, the bodies shuffled home to sleep fully dressed for an hour or two, before resuming their normal daily routines.

Probably 100 kegs, each containing 100 pounds of salt herring, were shipped to Duluth in hopes of earning a good price. Of course, the price dropped in the salt-herring market as soon as the fish were shipped. Instead of the two or three pennies a pound they'd expected, the islanders might get half a penny. It seemed to be Murphy's Law that "all commodities command a good price until there is some produced."

Seining happened only once a year. Even if another large school was sighted, no one was fool enough to report it. Next year, however, the process would repeat itself again.

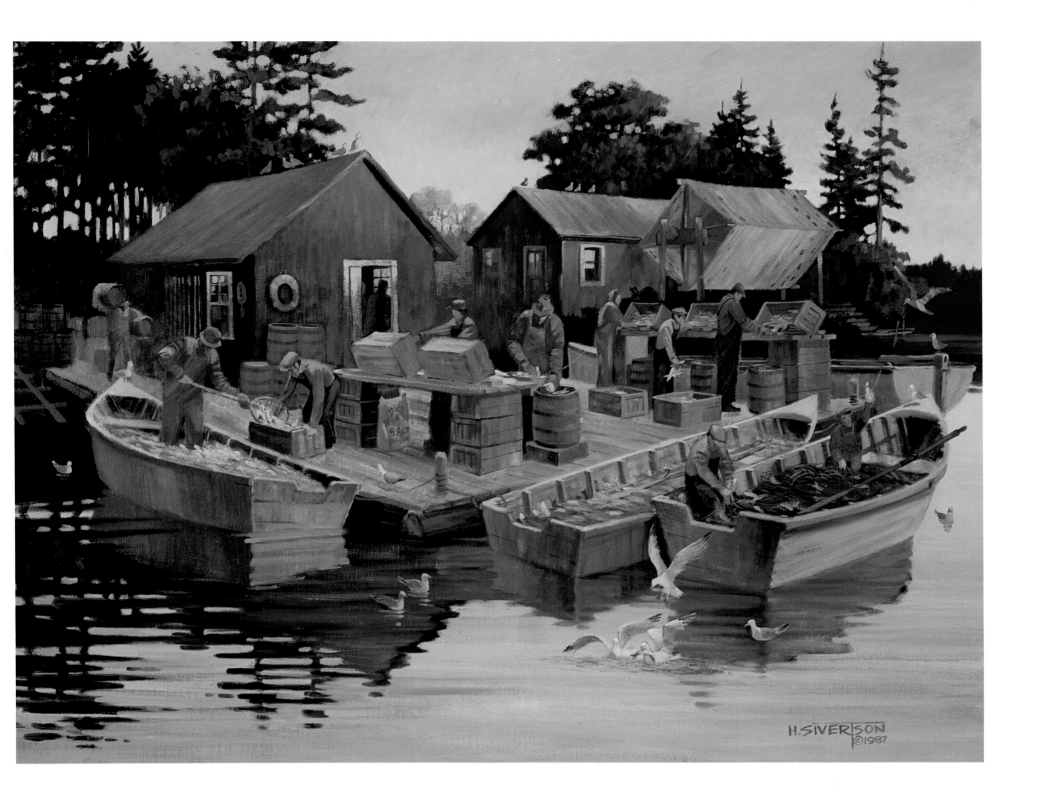

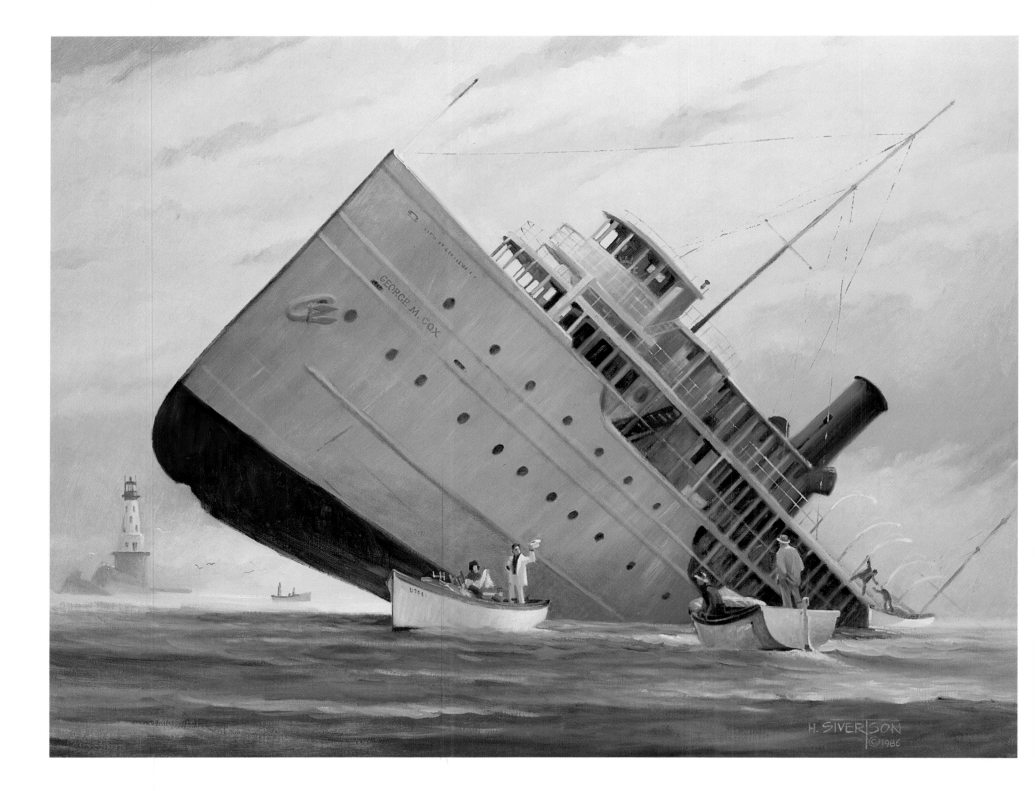

Raiding the *Cox*

Coming from Chicago on May 28, 1933, the *Cox* was a newly reconditioned cruise ship on her maiden voyage. On her way to Fort William in Ontario, she was rounding Isle Royale when, in thick ground-fog and at full speed, she drove her hull over 100 feet out of the water on Rock of Ages Reef, three miles southwest of Washington Harbor.

Some days later, Dad took us for a ride under the bow stem and keel of the partly sunken ship. I remember looking up at the dark underbelly of the enormous monster rising out of the sea, blocking out the sun and threatening to crash down on our small fishing boat. We waited breathlessly for her to break free and slide back into the depths, but she stayed in that crazy position until late fall storms gave her the nudge she needed to finish the burial.

In the meantime, the insurance company declared her a total loss and released the treacherous hulk to salvagers. Furniture, dishes, bedding, canvas, ropes, and tools were the rewards for those fishermen daring to scale her steep, slippery decks and enter the dark, creaking, dangerous catacombs in search of treasures.

Nels Wick and John Miller, a couple of fishermen from nearby Washington Harbor, went to collect their share of the booty. Tying their 24-foot boats to the doorknobs of staterooms now at water level, they scaled the deck of the slowly-twisting, groaning derelict and disappeared into its bowels.

Nels took what he thought was enough and was anxious to leave, but he couldn't raise John. He called for him many times without getting an answer, and began to believe the worst, when he saw the door to a stateroom start to open.

When John had disappeared into the stateroom, he was dressed in the plain, shabby clothes of the working fisherman. With his rubber clothes full of fish scales, and his hat pulled far down on his head, he looked like an old, disheveled, bent-over man, although he was probably only 40 or 50 years old.

Imagine Nels's surprise when a dapper, stately, distinguished man, dressed in a white suit, with a matching straw hat, spats, and a cane appeared on deck, stepped sprightly into his own boat, and drove off without a word!

While some of the wreckage of the *Cox* is still visible on top of the reef, most of the hull now lies underwater. No lives were lost, as all 118 of the crew and its passengers were rescued by John Soldenski, keeper of the Rock of Ages Lighthouse.

There are fifteen major sunken ships resting on the lake bottom around Isle Royale. A number of these vessels contributed parts of their structures and interiors to furnish the homes of island fishermen, before slipping finally beneath the waters.

Wash Day

When I was growing up in the 1930s, moose were plentiful to the point of being pesky. They had arrived on the island in the early 1900s by swimming and crossing on the ice. On Isle Royale, without the threat of natural enemies, the moose reproduced rapidly and soon displaced the indigenous caribou. The number of moose increased so fast that some had to be trapped and shipped back to the mainland to prevent overbrowsing, a threat to their own existence.

The huge 1,000-pound animals were intimidating but relatively harmless, except in spring when cows had calves, and in fall during the rut. Many days the moose browsed in our yard, keeping us small children confined to the house—underfoot of our mother who had plenty of work to do.

I remember, for instance, as a child, trapped inside the house, watching the walls tremble as a big moose walked back and forth outside, scratching its fur against the rough siding of our cabin. His big eye was right at the level of one little window... and that big eye kept going back and forth—first passing by one way, then back the other. I was fascinated by it, and pressed my face right up to the window so we could be eyeball to eyeball as he walked by.

Mother worked especially hard on wash days and worked most efficiently when children were outside playing, within earshot. Besides doing laundry for her own family, she washed clothes for the hired men as well. There was no running water or electricity so she had to haul 30 or 40 pails of water from the lake, each a trip of 100 or so yards, to fill wash tubs and copper boilers.

She heated water on the kerosene stove in a copper boiler and bailed it into tubs sitting on the hand wringer. Fels Naptha bars of soap were shaved into the laundry tub and clothes were scrubbed on a scrub-board by hand. It was strenuous work that had to be completed before her husband came home from the lake.

If a moose interrupted this flow of work, frightening the children into the house, something had to be done. A cow and calf were no match for an angry woman and, to the sound of spoon on dishpan and shouting children, the animals soon meandered back into the woods. Bulls were more of a problem, as antlers got tangled in the clothesline; dragging the works through the woods until breaking free. Mother had to follow, retrieving clothes and line from the belligerent bull and starting the wash over.

If she was lucky, Mother would have all the clothes hung out before the children announced they heard Dad's boat coming into the harbor. He'll want a hot meal immediately upon landing in a few minutes. She may fall asleep washing dishes by lamplight again tonight.

To do his part to help, my dad invented the first automatic washing machine on Isle Royale. He took a huge barrel and put a ten-horsepower outboard motor on it. He was smart enough to put a nice chicken-wire screen over the propeller so it wouldn't chew up the clothes.

He got it all set up and was real proud of it. He put in all the hot water, the soap, and the clothes himself. Of course, everyone gathered around for the first test. They wanted to see how this was going to work. So he cranked it up and let it go.

Of course, the motor was wide open, at full throttle. The next instant, there were clothes in the trees, clothes all around the yard, and soapsuds everywhere, over everything.

That was the last invention my dad came up with.

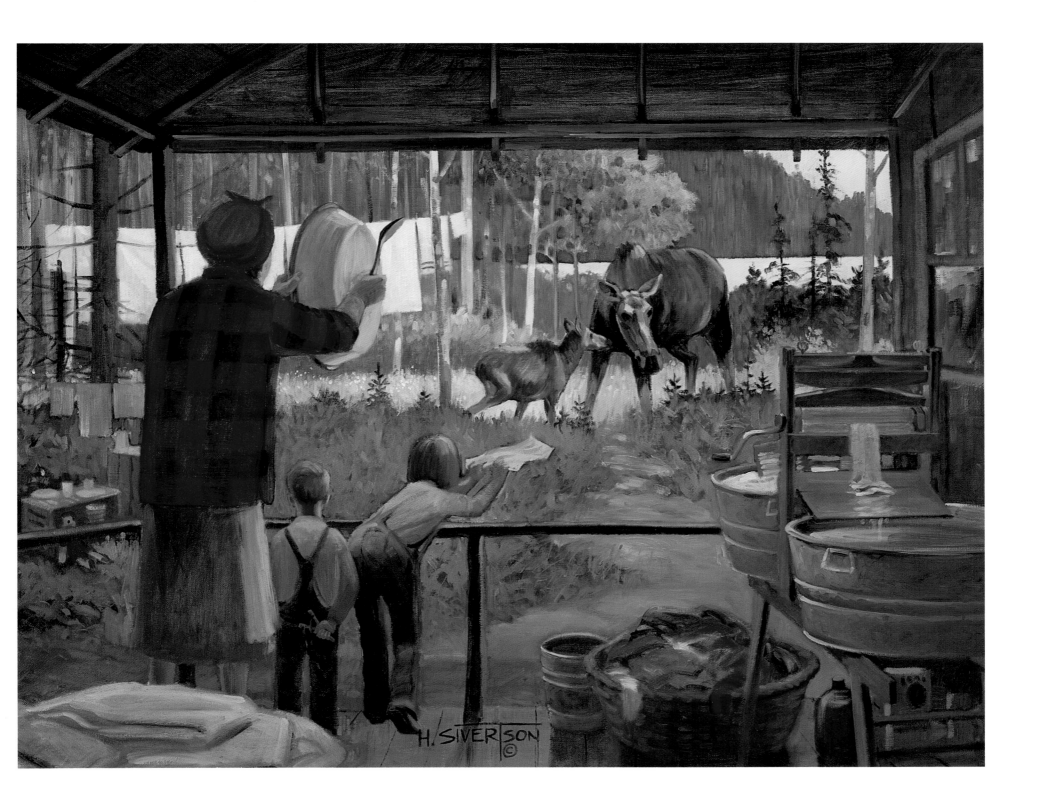

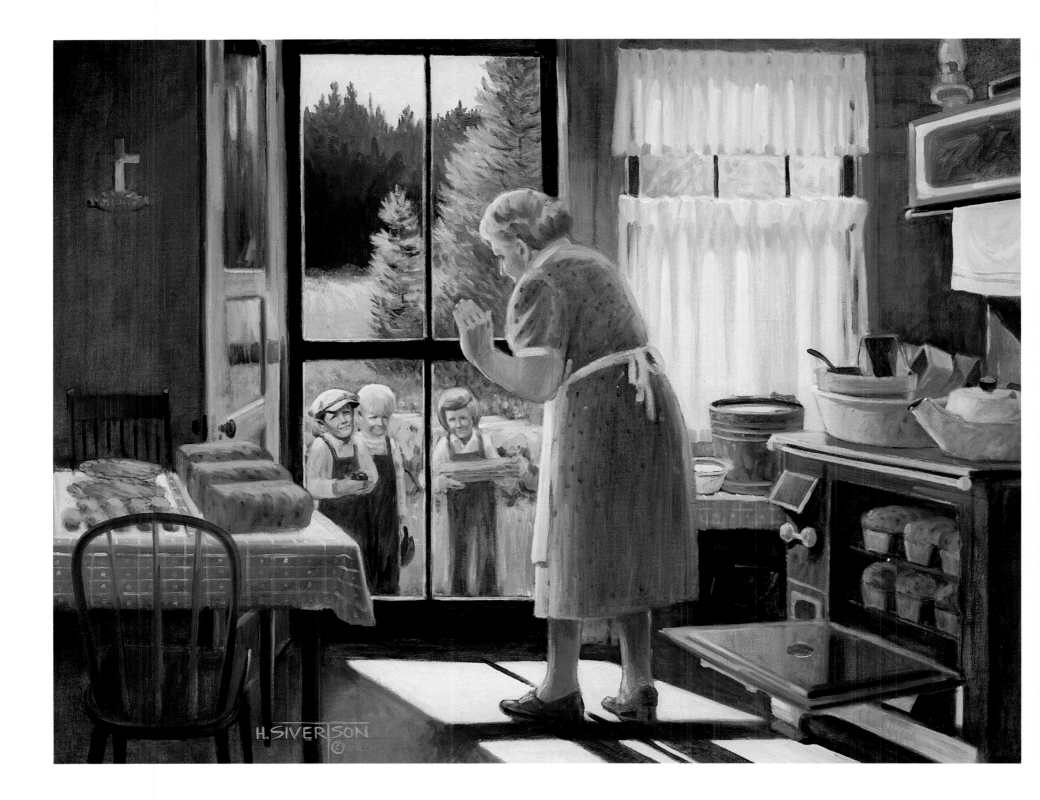

The Visitors

The island was a wonderful place to grow up but not necessarily a good place to raise children. From the kids' point of view, there was always something exciting and interesting to do. Parents, however, had the constant worry of their child drowning in the lake or getting lost in the woods.

Besides tagging around behind the grown-ups and learning their ways, we found ways to make our own fun. Island brats with slingshots, we hunted anything that moved. We caught sculpins and minnows in our bare hands, stole eggs from seagull nests, swam, and explored the woods and lakeshore. We also learned the art of "going visiting."

In the midst of play, we'd catch the scent of fresh baking. We followed the smell to its source and, sure enough, were invited in. If we minded our manners and offered to fetch a pail of water or bring in a couple pieces of firewood, we were treated to fresh bread and jelly, cookies, or fresh rolls. There were several ladies who baked on schedule and took pride in their specialties. It didn't take long before we knew who was baking what and when, and a visitation route was soon established.

The island folk seemed to enjoy us little kids and made us feel welcome. They also shared in disciplining us if we forgot our manners or were not following the rules. I recall one of the rules was to "empty all pockets of pet toads—outside!—before coming into the house."

Although the islanders were independent from the outside world, they depended on each other. The dozen or so families around Washington Harbor made their own rules, put out their own fires, settled disputes among themselves, and entertained each other. At spontaneous "sangerfests" and dances, gnarled but accomplished hands played sentimental and lively music on concertina and violin. At the end of each week, with a blast of the air horn rescued from the sunken steamship *America*, the Friday night poker game was announced. Everyone was invited to play, including children. We learned early in life not to draw to an inside straight.

Companionship was scarce and valued so everyone was invited to everything without discrimination.

Bible Class

There weren't any stores, schools, theaters, police or fire stations, city hall, hospitals, taverns, or churches on Isle Royale. The island families got along quite well without them.

The birth of babies was arranged to happen on the mainland but there were a few born on the island, as well as some very close calls. People who died all of a sudden were packed in ice and freighted to town. There was very little illness. Unless they contacted a contagious visitor, people didn't get sick, which was fortunate because there were no doctors either. In fact, before the National Park Service arrived, the only public servant on the island was the game warden.

Most islanders had a quiet faith in the Almighty that served them in times of danger or grief. They were religious but not overly pious. In an effort to raise the children with some sense of the Christian faith, some women would occasionally hold a Bible class. Grandma and one of the women would gather up a Bible and stand on the porch and holler to corral as many of the children within earshot as possible for an impromptu session.

"Within earshot" meant that a short scamper upwind or, if out in a boat, a few strokes of the oars would put a wary student out of range of the call to class. Occasionally, however, we were each caught in our turn and instructed in the ways of the faith.

This painting shows a typical house interior. Compared to the mainland, we lived simple, uncomplicated lives on the island. Our houses may not have been fancy but they were clean and functional. Inside walls were sometimes wrapped with tan kraft wrapping-paper to keep out the drafts that seeped through board walls. Calendar pictures, or family and island photographs, were tacked or taped on the wall or hung in inexpensive frames.

Rooms separated by curtains offered a little privacy. Wood stoves heated the house, drying wool socks and wet boots. Floors were scrubbed regularly, then covered with newspaper in areas of heavy traffic. Bright oilcloth covered the tables and cupboard shelves. Always, it seemed, there were flowers in abundance.

Each child had an orange crate for a clothes cabinet and a cot or twin bed to sleep on. There was always water in the buckets, food in the pantry, and warmth in the house. No one lived better than we did.

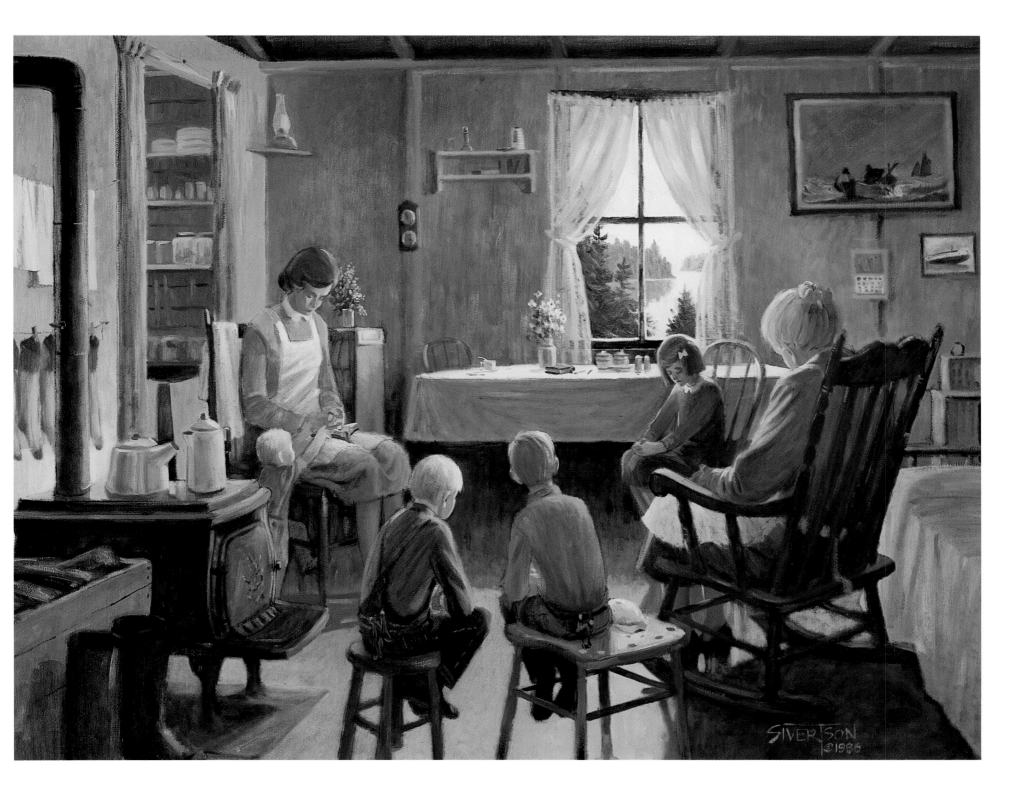

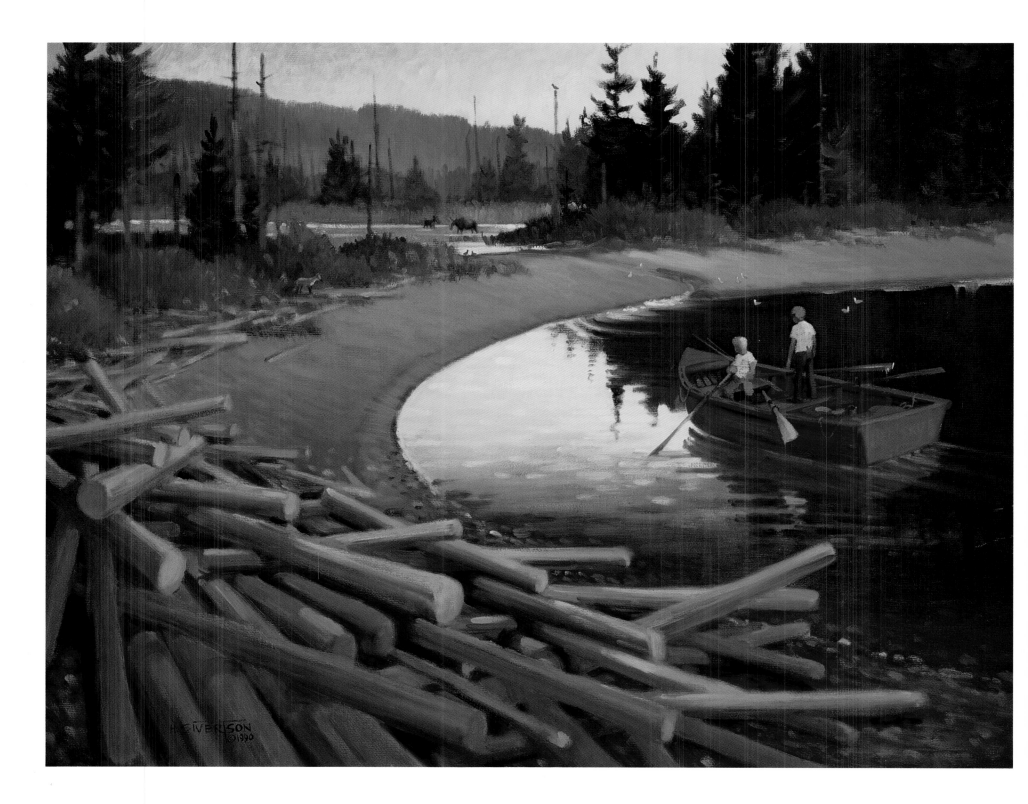

The Red Skiff

The fishing families of Isle Royale were surrounded by water. The streets and roads of the island were waterways and the only vehicles were boats. Children grew up less than 100 yards from the lake and were constantly warned about its dangers.

"Stay off the docks," or "Stay away from the water," were the last words we heard on our way to play. Fear and respect for the lake became part of us... but so did our love for boats.

The children of Isle Royale longed for a boat like those on the mainland longed for a bicycle. A boat was independence, adventure, the freedom to move about, to explore new lands and visit other kids on other islands. With a boat we could go speckle-trout fishing in Grace Creek, troll for lake trout, chase moose, beavers, and ducks, find eagle nests, steal seagull eggs, and maybe even have our own trout net.

Half-rotten, discarded skiffs and rowboats, lying about the island, stimulated already active imaginations and became pretend yachts, voyageur canoes, man-o-wars, and fish tugs. By the time we were nine or ten years, such dreams of play could become real if we could just get our parents to consider our constant requests. Then, finally, came the ultimate challenge: "If you can fix it, you can have it."

Roy Ruetan, manager of a summer hotel on Singer Island, gave my cousin Dick and me one of those marginal relics, a scow of a skiff whose only redeeming feature was that it was impossible to tip it over in the water. Our fathers looked her over, winked at each other, and gave their approval, knowing she'd never float again and that the experience would be beneficial to us.

To their dismay, after six weeks of constant labor, scraping, puttying, crude carpentering, caulking, and lots of red paint, we launched her. She floated! Our time had come, our prayers answered, our dreams realized. If we had known what it meant we would have called her "Nirvana"—but "Red Skiff" it was.

Our fathers had mixed emotions. They were proud of our accomplishment but afraid of the consequences. But they'd given their approval and a man's word was his bond. Their only alternative was to set stringent regulations to limit our risks. But all the rules were gradually broken as we strayed farther from the harbor to new adventures.

We had to be rescued on more than one occasion. Sometimes we didn't pull the skiff far enough up on the beach while we went off exploring new lands. Wind or waves took her to sea without us, leaving us stranded. Or during play we'd forget to tie the skiff securely to the dock, and we'd soon spot her drifting out of the harbor. Embarrassment and scoldings were the greatest dangers we faced, and rescue came with mixed emotions.

But soon the harbor folks got used to seeing the comings and goings of the red skiff with two boys rowing—or sometimes makeshift sailing—and fears subsided. Dick and I had our yacht, our clipper ship, our man-o-war. What glorious days those were!

T'dora's Rock Garden

Small, colorful flower gardens were like jewels in the island wilderness. My grandmother, Theodora Sivertson, was just one of the island's many loving caretakers.

Most fishermen's wives took time and pride in their well-kept garden plots of sweet william, nasturtium, pansies, phlox, and roses. Pushing fishing paraphernalia aside, they cultivated a thin layer of soil between rocks and boulders. Plots were ringed with white cobblestones selected from island beaches. By midsummer, a cheerful vase of flowers adorned each oilcloth-covered table in the humble island homes.

The season was short and the soil too thin to grow much besides flowers, but some women succeeded in creating vegetable gardens in protected areas.

The sight and smell of flowers symbolized the change of seasons and work habits of the fishermen. The hectic hookline fishing season was over and preparation for gill-net fishing season had begun. The main lines were dried on reels. Snells were bunched and hung on fish-house walls, hanks of seaming twine and buoy-line stored away, and buoys laid on racks to dry. New nets were seamed, corked, and leaded.

The heavy wool clothes and rubber boots were replaced with lighter clothes and street shoes. Sometimes on warmer days, the fishermen went shirtless, revealing white muscular bodies accented by dark weathered hands and faces. Although still working from sun to sun, coffee breaks and leisurely conversation were more frequent.

It was a good time for children, too. Water in protected shallow bays warmed almost enough for swimming. We swam until our bodies turned blue and shook uncontrollably. Hypothermia, though unheard of, was a daily condition. The sunbath afterwards saved our lives. Rowing, sailing, exploring, speckle-trout fishing, and pursuing moose, beaver, squirrel and other wild things filled our warm summer days... after chores, of course.

Likewise, the women found time to go visiting, to trade news, recipes, and flowers. Rose-bush roots and slips from the garden of my grandmother found their way to all corners of Isle Royale. Today, her flowers still grow wild on rocky harbors where fishermen's houses once stood.

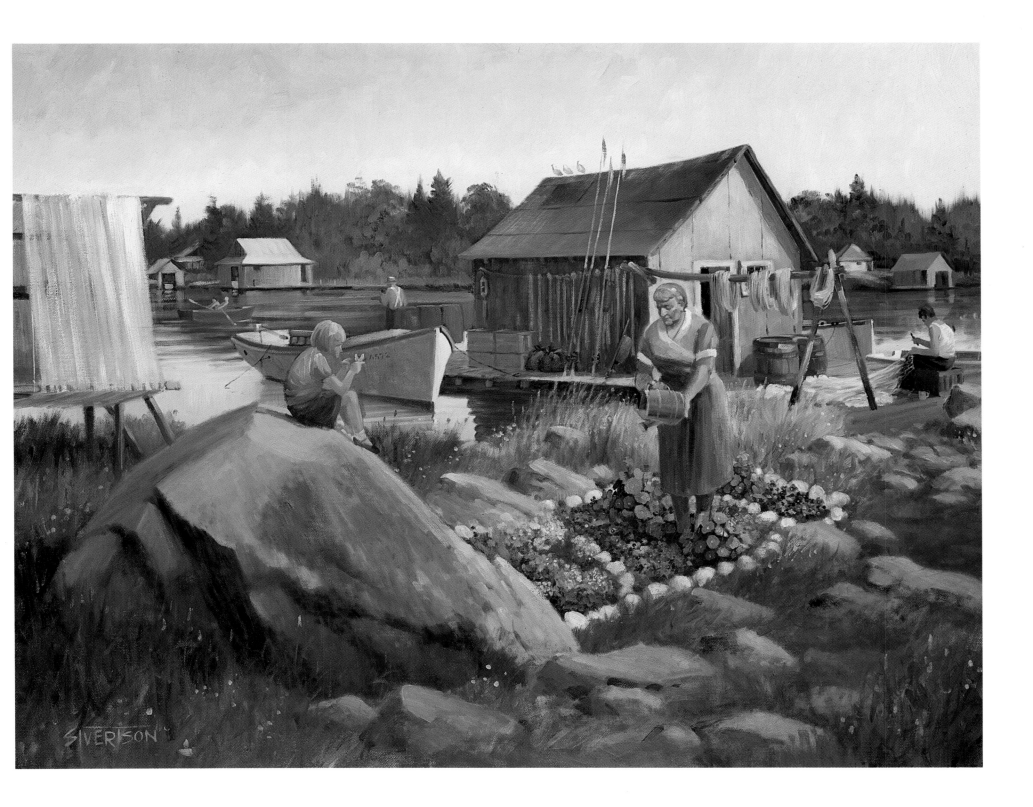

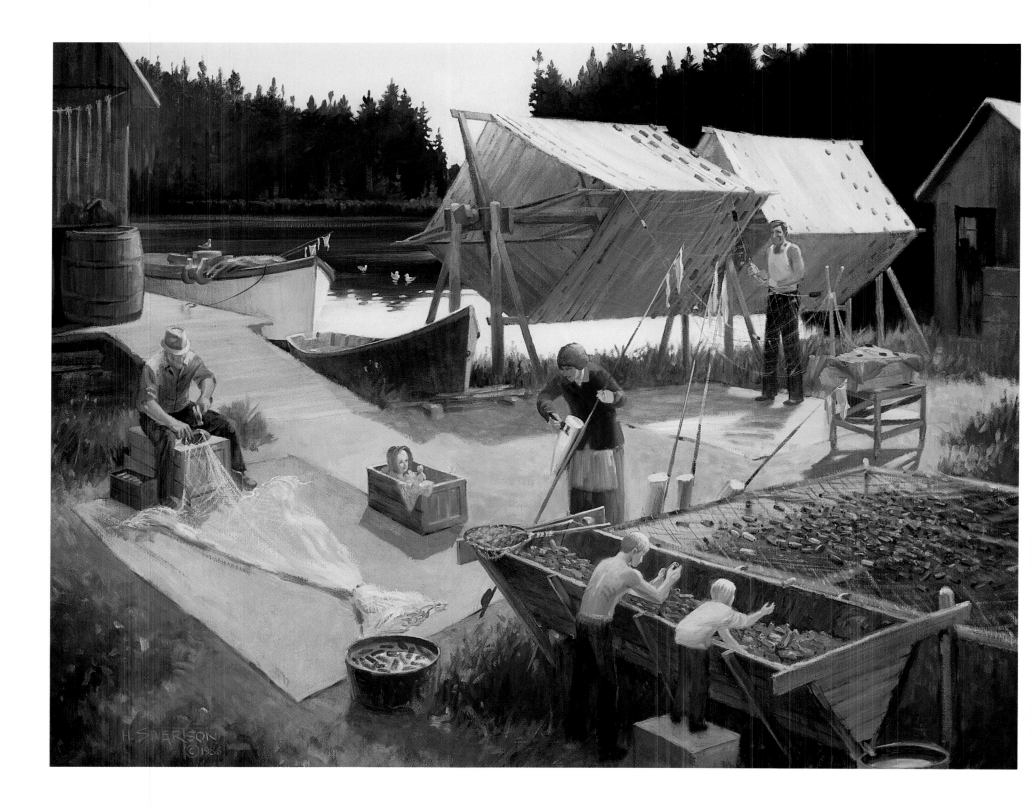

Shore Work

Children were not paid for regular chores, but we were paid for any work connected with fishing. Building wooden fish boxes at five cents each, rubbing corks at ten cents per hour, and helping on the lake for half a penny per pound of fish caught were ways we earned money as young kids.

Getting rigged up for the fall gill-net fishing involved the entire family. Old trout nets were taken from the net house and mended, scrubbed clean of last year's lake moss, and reeled up on net reels. Freshly-oiled cedar corks were attached, then the nets were pulled down in boxes, ready for use. Buoys were painted, the license number stenciled on, and flags replaced if necessary. Anchors and anchor lines were made ready. New nets were seamed and lead weights molded on the forge, then attached.

Fishermen used cedar corks until the mid-1940s when aluminum, then plastic, became common. The old cedar corks had to be linseed-oiled every year to keep them from getting waterlogged and sinking. A tub of hot oil was heated, and the corks were dumped in, then dipped out with a dip net and dumped into a large drain trough. Children then rubbed the corks, smoothing out excess oil and blisters. Each cork was twisted then flopped end-for-end between the youngster's hands and thrown to dry on the cork rack. It was a monotonous rhythmic motion, rubbing one cork every two seconds, and it soon became a game if two or more kids were involved.

We found other ways as well to earn money. We combed the beaches in search of anything that might prove useful to an adult. During World War II, we also collected scrap iron and aluminum foil for the war effort.

In the 1930s, part of the bow from the sunken ship *America* had washed up on our beach. It had a 20-foot piece of heavy angle-iron attached to it that would "scrap out" for about 20 dollars, if my cousin Dick and I could free it from the wreck.

We asked my Dad's advice when he was in a hurry to go on the lake and he facetiously suggested we "chop it off." We used his new axe and after eight hours of constant chopping and re-sharpening the axe, we hacked the angle iron in two. We hauled it to the *Winyah* and collected.

Of course, Dad's new axe was totally ruined but he didn't scold us. He admitted his poor judgment and gave us straight answers from then on.

The *America* Connection

In the early 1900s, hundreds of fishermen's homesteads clung to the edges of the North Shore and Isle Royale, nestled in tiny niches or sheltered coves that offered enough protection to launch a skiff and accommodate a fish house.

In those pioneering days, the *America* was the best connection between the settlers and civilization. She ran night and day, six days a week, in all kinds of weather from "ice out" in April until December. Besides her main ports of call, she kept a tight schedule of rendezvous with hundreds of fishermen in skiffs from Duluth to Port Arthur and Isle Royale. Three times a week she delivered mail, freight, supplies, passengers, cattle, and other necessities, then on the return trip picked up the fishermen's catch of fish.

I remember vividly my uncle describing what it was like to rendezvous on a foggy day with the *America* out on the lake. "You knew she was coming by a toot of her whistle... the sound of her engine checking down... the swish of water against her bow... muffled voices of passengers on deck... and the clunk of the sliding hatch opening a hole in the side of the giant, gray shape looming into view."

While loading and unloading, news was exchanged with the deck hands concerning happenings along the North Shore and at Isle Royale. The *America* carried messages from neighbors and relatives about meetings, social events, family doings, and fish reports. By knowing how much fish their neighbors were shipping, fishermen could predict fish movements and make adjustments in their fishing strategy accordingly.

The 182-foot steamship was owned by Booth Fisheries and operated by the United States and Dominion Transportation Company from 1903 until she hit her final reef and sank at Washington Harbor in 1928. From 1903 until 1909, she was piloted by Captain "Fog King" Hector, after which Captain "Indian" Smith took command until she sank.

The *America* was palatial with a large ornate dining salon, fine bar, and gambling room where gracious ladies in all their finery pulled the handles on one-armed bandits next to bankers, loggers, trappers, and fishermen.

My grandparents Sam and Dora Sivertson were aboard the *America* the night she hit a small reef and had to be beached in the north gap between the mainland and Thompson Island. They were returning from Duluth where Sam had just been treated for a broken leg. About 3:00 a.m., they were awakened by the noise and shudder of the ship's hull as it struck the reef. When it started sinking, Captain Smith gave orders to beach the *America*.

Sam Sivertson guided his lifeboat into nearby Washington Harbor to wake the fishermen to help in the rescue. Between the *America*'s screaming steam-whistle and Grandpa's shouting, the fishermen were alerted and responded immediately. However, the 30 people on board were already in the remaining lifeboats and on their way to harbor and safety. Only Doctor Clay's dog went down a few minutes later when the ship slid out of sight.

Underwater, the *America* belched up her cargo of fruit which floated around Washington Harbor for weeks, more than satisfying the island families' need for bananas, strawberries, and cantaloupe.

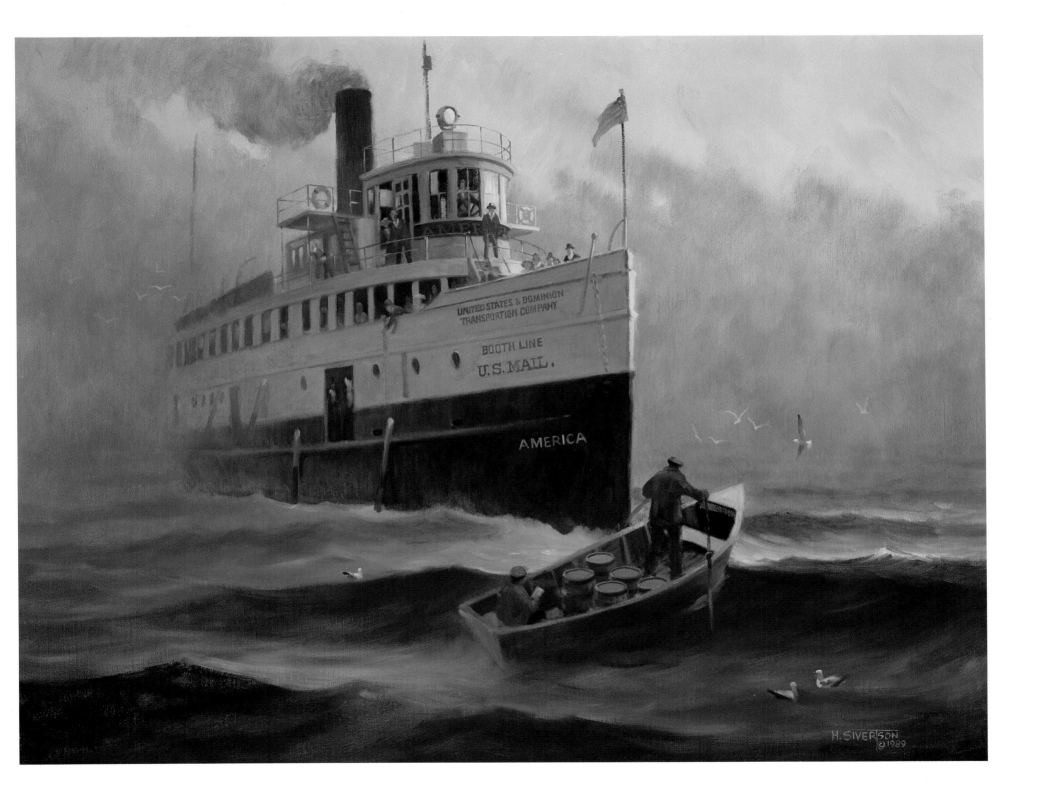

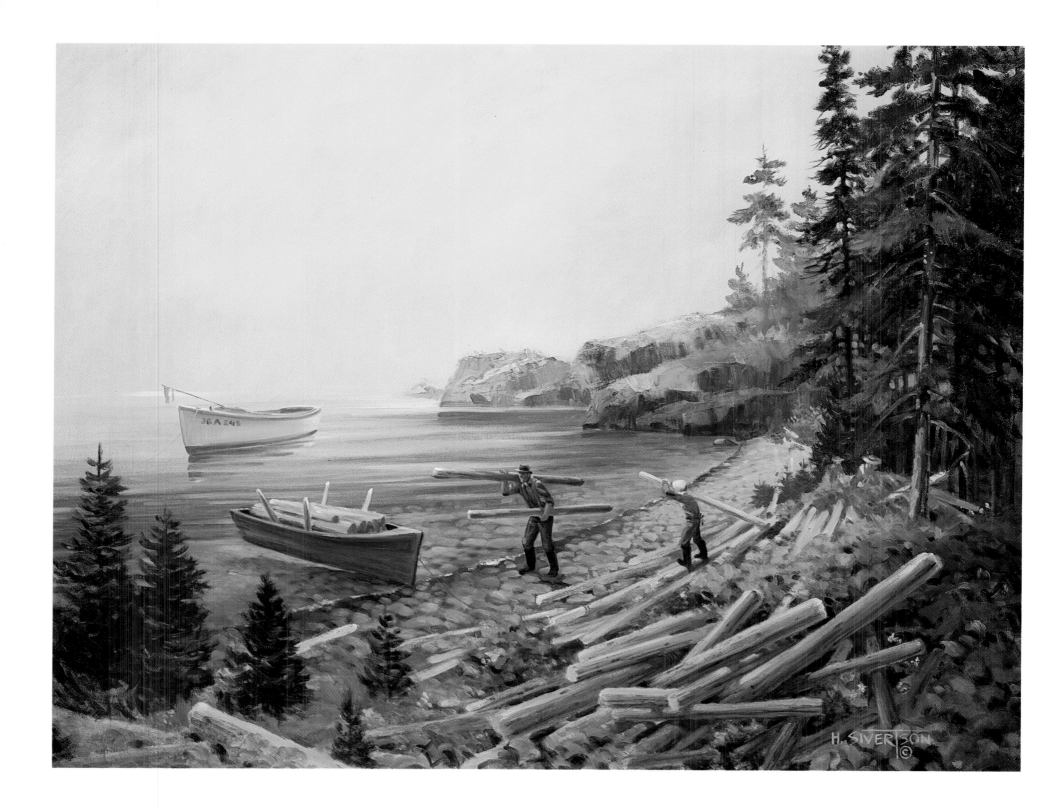

Picking Pulpwood

Pulpwood sticks were a danger and a blessing to Isle Royale fishermen. Floating by the thousands in island waters, the water-soaked logs posed a danger to navigation, threatening boat hulls and propellers if struck.

Once the pulpwood sticks washed up on beaches, however, they furnished fishermen with firewood and the raw materials to construct buildings, dock cribs, boat slides, net reels, and cork racks.

The sticks were gifts from the logging industry around the North Shore. Loggers in Minnesota and Ontario cut spruce, balsam, and aspen into 4-foot to 20-foot lengths, which were floated down-river or trucked to the Lake Superior shoreline. Huge floating corrals were made in the water by chaining long boom-logs, end to end, in a giant circle of several acres. Thousands of cords of pulpwood sticks were then dumped into the middle of the corral to make up a "raft." Steam-powered tugs slowly towed the rafts to Lake Superior paper mills. Occasionally, when storms broke up the rafts, the pulpwood sticks scattered over the lake to float until waterlogged or washed up on beaches like those at Isle Royale.

The fishermen set aside one or two calm days during midsummer to collect enough pulpwood sticks for the year. Only when seas were dead calm could we land our skiff on a rock beach for loading. As the supply of pulpwood sticks far exceeded the demand, the fishermen selected sticks only from rocky beaches. Pulpwood sticks on sandy beaches were impregnated with sand and would dull saw blades if cut.

Pulpwood picking was a chance for a family outing. We spent some pleasant moments enjoying a picnic lunch, berry gathering, and agate or greenstone hunting.

Later, as our skiff was loaded, we moved it farther off the beach, heaping it with logs until the gunwales were only inches out of the water. The skiff was then floated to the gas boat which was anchored offshore, and towed home. The wood was stacked neatly on the wood dock to be cut on the gas-powered circular saw at a later time.

Although the work was hard, it seemed an exciting break in the usual routine. Pulpwood-picking day was treated almost as a holiday.

Fourth of July

With his Scandinavian accent, my Grandpa called it the "Fort of Yuly" or, for short, just "The Fort." The Norwegian fishermen on the island celebrated two independence days: Norway's on the 17th of May, and the American holiday on the 4th of July. The latter was their only actual "day off" during nine months of fishing and they made the best of it.

"The Fort" marked a natural transition in the island's annual cycle. Hooklines and bait nets were pulled in, and gill-net fishing of late summer hadn't gotten underway yet. This was reason enough to celebrate.

Isle Royale fishermen planned for "The Fort" far in advance by shipping fish to several fish companies in Duluth. They shipped to more than one company not only to "keep them honest," but also because each company would send gifts to all their fish suppliers for the Fourth. This included a quart of brandy or whiskey, a case of beer and pop, ten gallons of ice cream, and a watermelon. Multiply that by two or three fish companies a fisherman shipped to, and you get the idea. The goal then was to get rid of the gifts in one day. The fishermen didn't see any reason to have anything left over on the Fifth.

On the big holiday, we all got to "sleep in" until 6:00 in the morning. After a leisurely breakfast, the gas boat was scrubbed, water was heated for baths, and we dressed in our Sunday best. "Gussied up," we boarded our gas boat for a morning round of visiting neighbor families in the harbor to share our gifts with each other. Old friends got reacquainted in a relaxed sociable atmosphere. If there was an old quarrel, the two fishermen involved might settle it on this visit. They punched each other in the nose, then re-establish their friendship with a "dram" or two of "viskey."

By noon all this visiting was done. It was time for the baseball game. In Washington Harbor, the "Boot Ayland" (Booth Island) team played the Singer Island team.

The Game was played in a clearing full of rocks, hummocks of tall grass, and bushes. First base was a lilac bush, a rock was second, and the outhouse, third. The fishermen gave a good imitation of the Keystone Cops playing something slightly resembling baseball. Each carried a "pint" in his back pocket and every play, good or bad, was celebrated with a "dram." If somebody actually managed to hit the ball, everyone nearby would run to chase it, often disappearing for awhile in the tall grass.

The painting here shows a typical ruse—tempting Olaf to steal second base. The game was usually called off to go on the picnic. No one was sure who won or lost.

Boats were loaded with food, beverages, and people for a short ride to a gravel beach where a picnic would be prepared while concertinas and fiddles were taken out for a "sangerfest" of old-country songs.

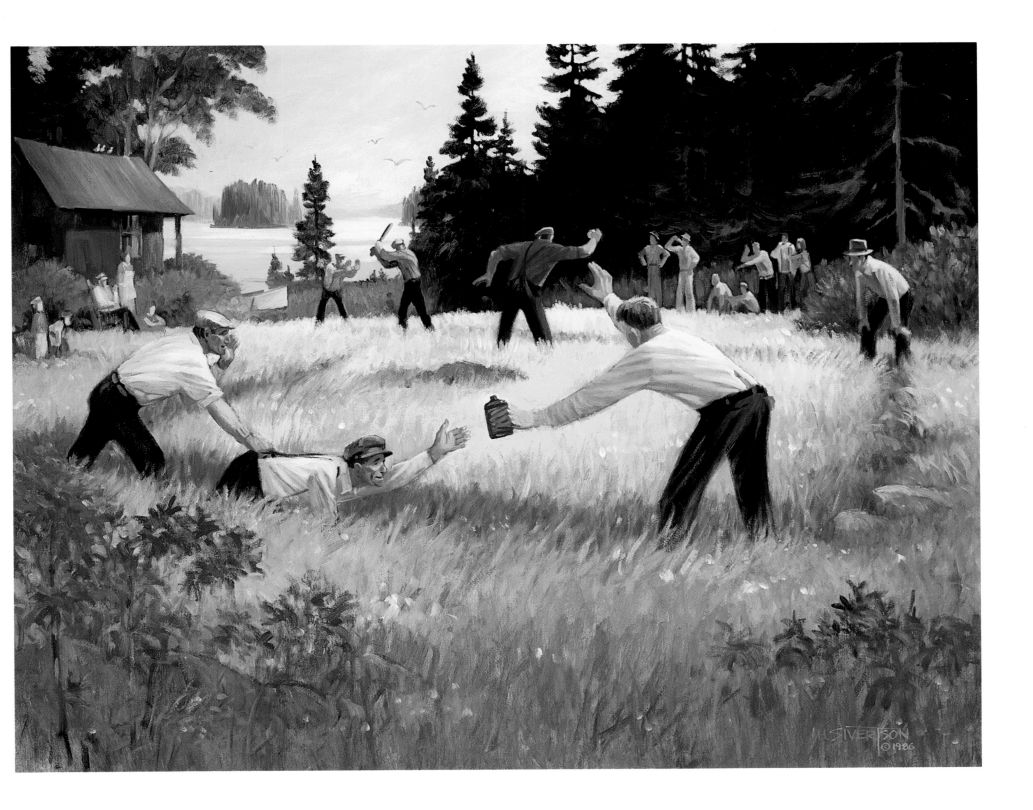

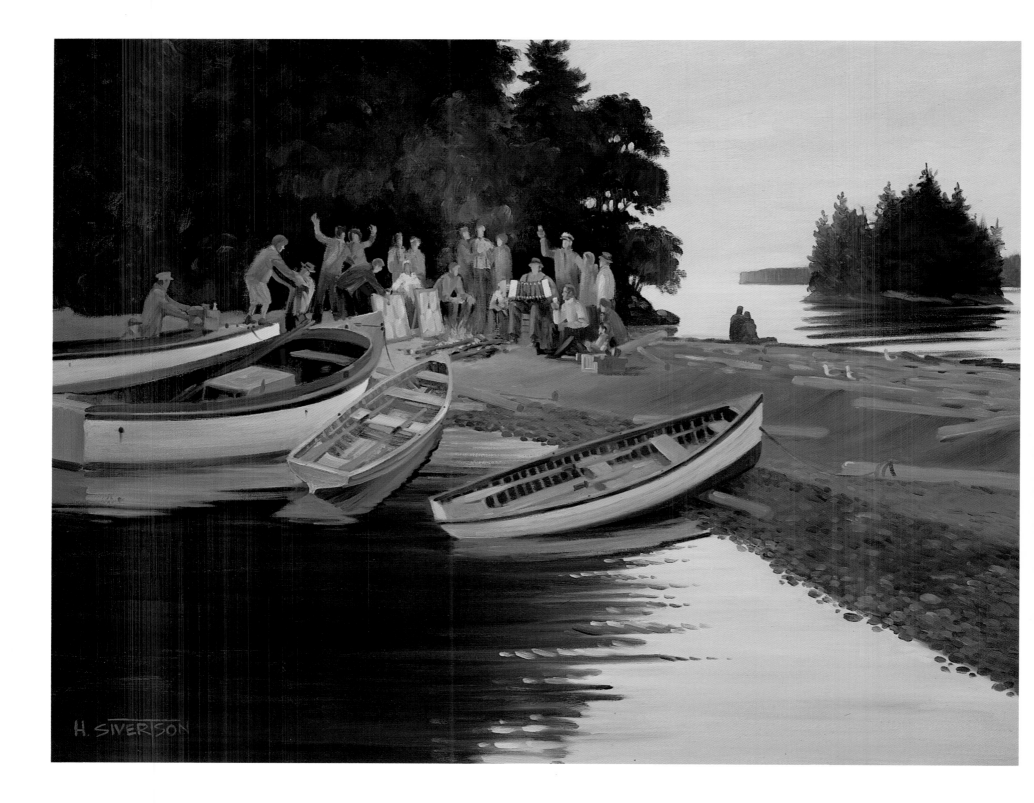

Planked Fish and Sangerfest

After the Fourth of July ball game, we moved the celebration to a small island with a sand beach sheltered from the wind, for a potluck picnic featuring Planked Fish. Fishing families and summer folks alike arrived in gas boats, skiffs, rowboats, and pleasure boats. Everyone pitched in and gathered driftwood for fire and seating. They wired lake-trout fillets to birch planks for roasting, helped unload boats, and sorted out food.

The planked fish were propped up facing the bonfire, starting about ten feet away. As the fish dried and the fire burned lower, the planks were moved closer to the coals. The fish were basted and seasoned, then left to cook slowly during the singing fest.

The Scandinavian fishermen loved to sing on most any occasion, especially if there was a concertina or violin to keep them on course. Often in the evenings, our family and others would gather to watch the sunset, and sing sentimental songs from the Old Country, our voices echoing among the islands. And so, a sangerfest was inevitable at the Fourth of July picnic.

In keeping with the festive nature of the occasion, the fishermen started with high-spirited drinking songs such as "Skoal, Skoal, Skoal." Other favorites included "Spinn, Spinn, Spinn, Datter Min" and the humorous "Nikolina." They also sang patriotic songs like "God Bless America" and the Norwegian anthem, "Ja Vi Elsker Dette Landet," with gusto. Attempts at harmony grew more convincing as the party progressed.

After dinner, as the sun began to set, the music continued in a more mellow mood. Sentimental old-country ballads were sung by rough fishermen, fellows in their forties and fifties who had left their homeland as youngsters, burning their bridges behind them. Never again would they return to visit family or see the soaring mountains and deep fjords of the Norwegian coast. Isle Royale became their home but the fond memories of the Old Country still remained.

When the sentimental strains of "Hälsa Dem Där Hemma" echoed through the islands, tears ran down the cheeks of the toughest among them. It was a sailor's lament upon leaving his homeland aboard ship for a new land. "On the deck I stand each night, while the stars are shining bright, far away from friends and home, sadly do I roam." The song was sung to a swallow flying back to the Old Country, asking it to "greet my little sister, greet my brother, too, greet all the children, Father and Mother, too."

Embarrassed by their own tears, those tough old guys hugged each other. Some drifted off to watch the sun set through wet eyes. Others walked off into the woods to grieve by themselves.

The sounds of boats leaving the beach signaled the trip back to the harbor for the dance that lasted till 2:00 or 3:00 in the morning. The fishermen and their families then climbed into bed for a couple hours of sleep before work resumed once more.

Lifting Trout Nets

In late summer, lake trout moved from the deep cold waters of the open lake to warmer, shallower waters. By fall, the fish congregated on their spawning reefs in great numbers, and so did the fishermen. Boats from Washington Harbor, Long Point, and Fisherman's Home covered McCormick's Reef with gill nets. Each fisherman set all the nets he could manage. Competition was keen as the boats worked close by each other in a confined area over the shallow reefs.

During the peak of spawning activity in mid-October, the Michigan Conservation Department closed the fishing season each year for three weeks to ensure a healthy lake trout population. After the "closed season," gill-net fishing resumed again in November. If fall storms didn't destroy his nets, the fisherman had his best chance to make a profit in the big harvests of fall.

The trout gill-net was about 300 feet long and sat on the lake bottom like a tennis net or a fence. It was called a gill net because the five- to six-inch meshes were difficult for fish to see at night and they got tangled and caught, usually by the gills. Cedar corks were tied to the top cork-line and lead weights were attached to the bottom lead-line. Each 300-foot net was called a "piece," and a "gang" was one or more "pieces" tied together and set as a unit.

In fall, the nets were set on reefs, usually in only 20 to 50 feet of water. Each boat of two fishermen might set 40 nets on average. To lift and check a net, one man pulled the net up into the boat over a roller temporarily attached to the stern in place of rudder and tiller. The second man "picked" the fish and piled the net neatly for resetting.

It was back-breaking work lifting nets heavy with lake moss and fish. When they finished lifting a whole "gang," the roller was removed, the rudder and tiller replaced, and the net was reset, usually in the same location if the fishing was good.

Although a lot of fish were harvested during the fall season, the fishermen also collected spawn and milt and fertilized them for the Conservation Department, which hatched the eggs in hatcheries and replanted the fry in the lake. Most fishermen were good conservationists. They were proud of harvesting food for America's tables and equally proud to replenish far more of the resource than they took.

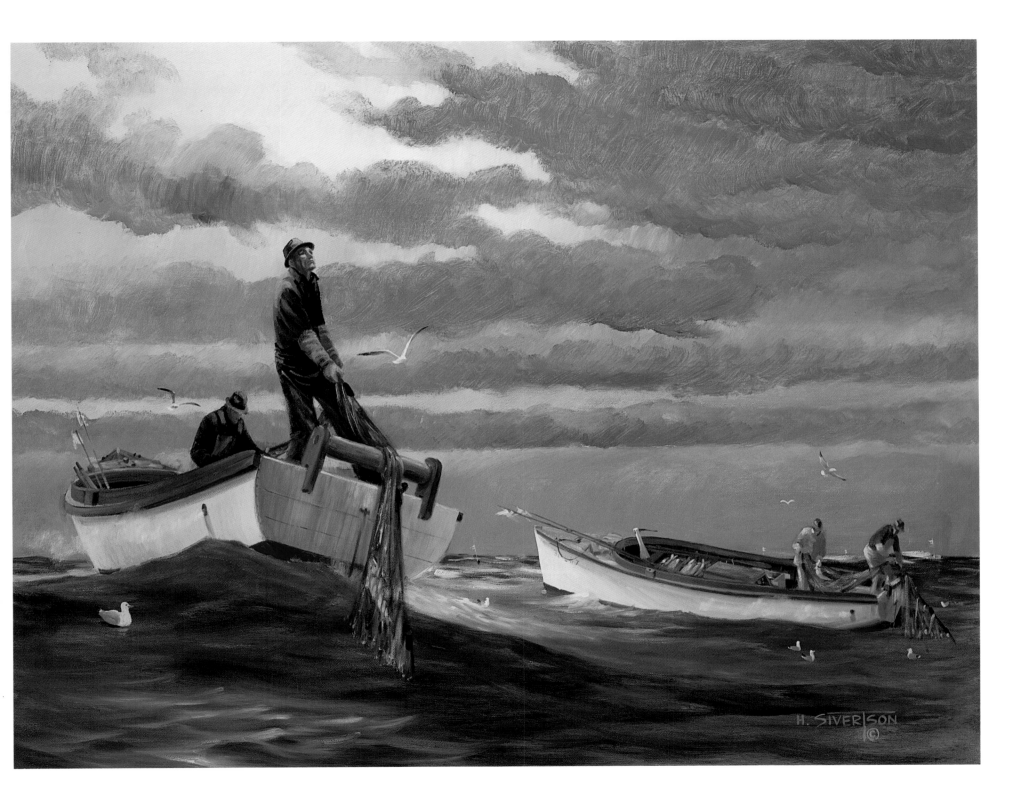

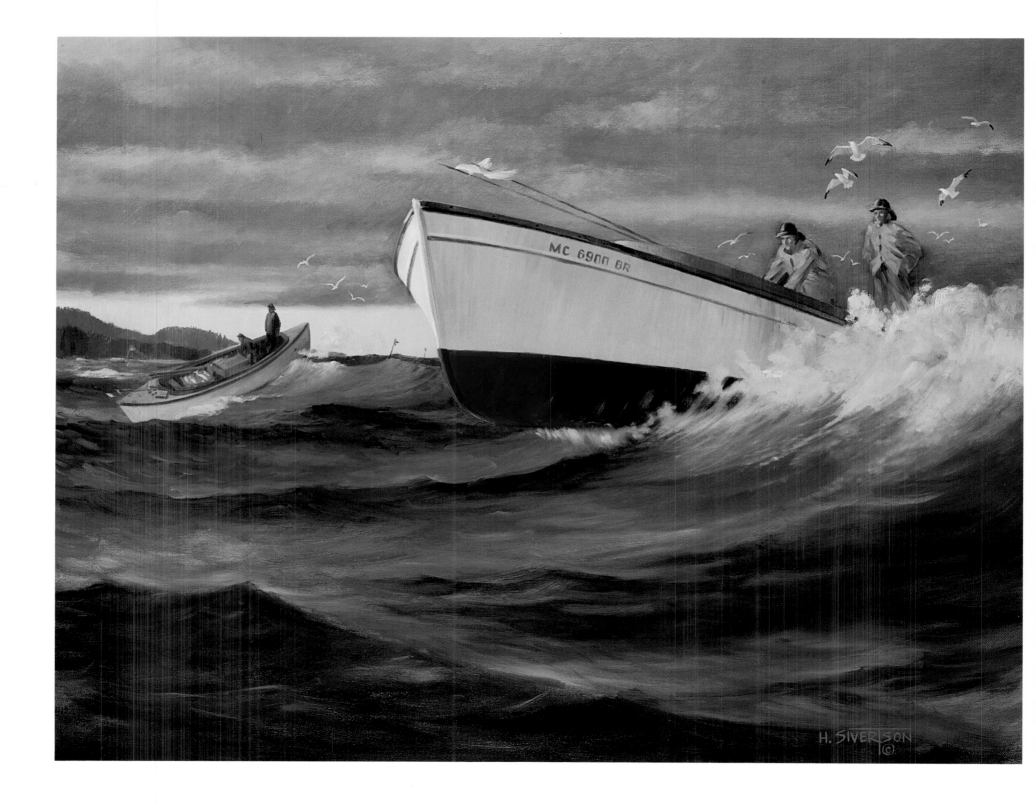

Pounding Home

The ride home from McCormick's Reef in late afternoon was often rough and wet. Lake winds usually increased by midday. The fishermen raced the weather, trying to complete work on the lake before the afternoon winds created sharp seas for a wet, jarring ride home. The constant spray of cold water found its way through cracks and openings in rubber clothes and soaked through to the skin.

More of a threat, however, was the constant pounding of semi-rotten hulls on hard seas. This pounding could cause serious damage to the boats. It was especially dangerous in the fall when high winds created huge seas that threatened life if course and speed were not regulated properly.

When heading into the seas, one fisherman stood on the rear seat, steering with tiller between his knees to hit the wave at the correct angle. He had nothing to hang on to and maintained his balance by keeping knees slightly bent, like a skier, absorbing motion and shock while shouting instructions to the engine man. "Check'er down," "Speed'er up," "Let'er go," were commands to adjust boat-speed to accommodate the oncoming seas. "Check'er down" was needed when the next sea was large, "Let'er go" during smaller seas.

Most fishermen could not afford new boats and motors. The wooden hulls suffered from dry-rot in ribs and planks. The converted automobile engines used were not quite powerful enough for the job they had to do, and were often held together with hay wire. Many a fisherman found himself nursing an engine and babying a boat for "just one more season." The men's lives literally depended on their skill in boat handling and maintenance. An error in judgment could have very serious consequences.

The painting shows two basic hull designs for gas boats. The boat in the distance is a double-ender with a sharp stern. The foreground boat has a square stern of more recent design. Boat builders on the North Shore like the Hills, Scotts, and Linds built most of the gas boats for Isle Royale. Various design configurations appealed to different fishermen. Length and width were similar but the sheer, flare, bow angle, square or sharp stern, and freeboard design depended on individual preference. "Good" boat design was always a topic of discussion (argument) whenever two or more fishermen gathered together.

Each fisherman knew his boat intimately, like a cowboy knew his horse. He knew instinctively how much weather it could handle and when he had to run for shelter or tie up to a buoy and "ride it out."

Refuge

Sudden storms occasionally caught the usually weather-wise fishermen on the lake by surprise, prohibiting their return home. An unexpected strong wind could build huge waves rapidly, forcing the men to drop their nets and seek the nearest shelter to wait out the storm.

Long Point was the nearest refuge for my father and other Washington Harbor fishermen caught on McCormick's Reef in a strong "southwester." By threading a network of channels between shallow reefs, boats could navigate behind a rocky point for shelter from the pounding seas. Here, there was room for several boats to tie up with bows to the ledge and sterns anchored out, holding the boats away from the rock.

As each boat found quiet refuge from the raging storm, a sense of well-being replaced feelings of anxiety. When all boats known to be in the area were accounted for, the men pumped water from bilges and straightened gear tossed about by the storm. It was a time for coffee, sandwiches, and light-hearted conversation, each man feeling euphoric over his deliverance from the unspeakable fate. Engines and boats were praised for their performance and dependability under fire. After the realization of their own safety, the fishermen soon began to worry about the loved ones back home who were worried about them.

They could be weathered in for hours or days, but usually the storms that came up suddenly and without warning passed over just as rapidly, allowing the fishermen to return home in a few hours. Even if the storm continued, the steep, cresting waves would grow larger, changing their configuration to higher but longer seas, like a roller coaster, more navigable for the small open boats.

The folks at home generally expected the worst when boats were late and were greatly relieved when the lost boats finally came into view.

Because their lives and livelihoods depended on the weather, fishermen became good forecasters. But sometimes they misjudged the timing and the intensity of a storm or took chances trying to get nets lifted before it hit. When they guessed wrong, they suffered for it.

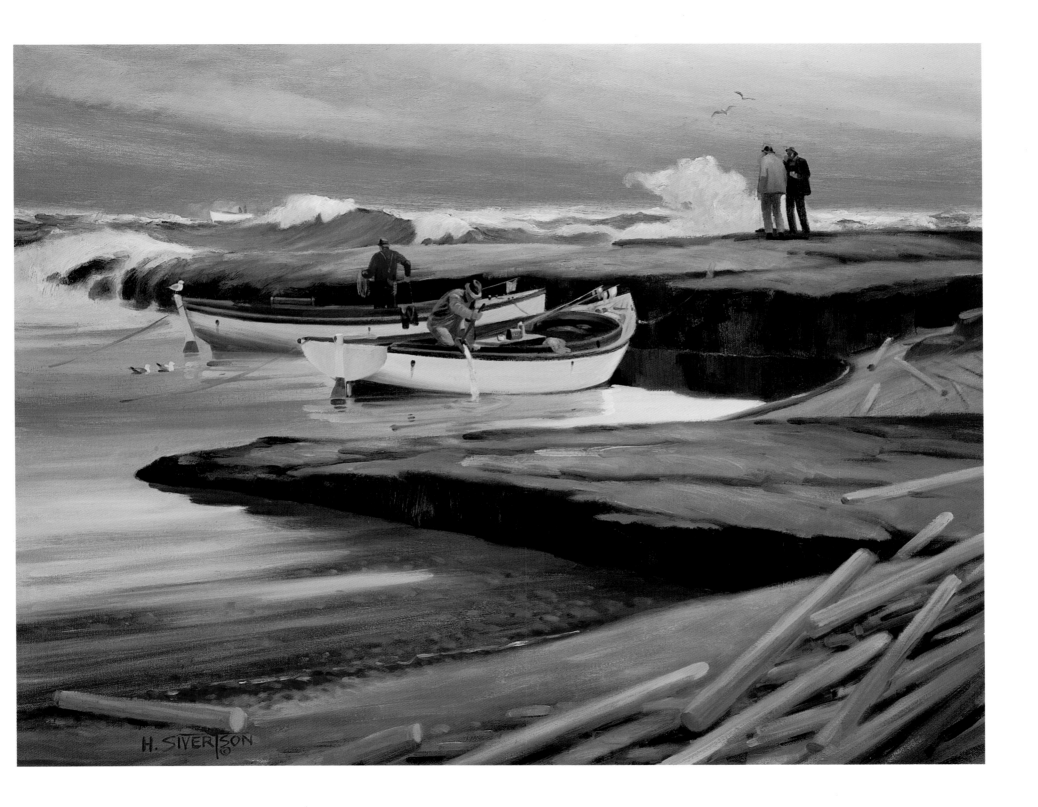

H. Sivertson

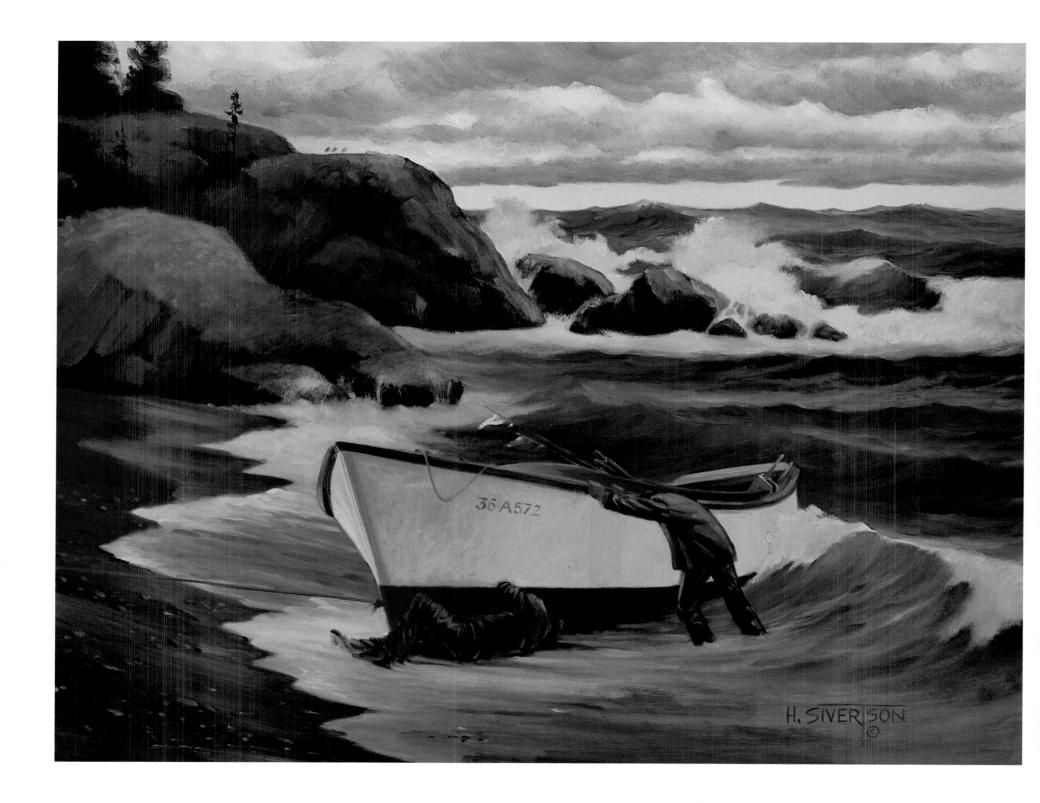

36 A572

H. Siverson

Emergency Repairs

She's leaking too bad, Carl! We'll have to run her on the beach," shouted Einar over the roar of the engine and the howl of the storm.

Sometimes the worst fears of a fisherman were realized as a small boat began to break apart from constant pounding in heavy seas. The "Swedes," Carl and Einar Ekmark, were beating home against a heavy southwester when water filled their boat faster than they could pump or bail it out.

They were fourteen miles from home at McCormick's Reef when the storm came up. All the other boats had left for home when the Swedes decided to follow suit. The wind increased in velocity and sharp seas grew to gigantic proportions. The 24-foot open gas-boat dropped off the backside of a 15-foot sea, slamming into the trough on the other side. A lot of water came over the bow and now, dangerously, also from an unseen source under the floor boards, threatening to sink the boat in minutes. Spotting a semi-sheltered gravel beach close by, they ran the sinking boat aground on the beach at full throttle.

Without speaking a word, almost as if they'd rehearsed their actions, they grabbed tools, cup grease, and burlap sacks, jumped to the beach, tied the boat to a tree, and heeled the boat on her side. They stuffed greasy sacks in the hole under the portion of the keel that had become detached, then nailed the keel back on.

Together, they struggled to launch the boat back into the raging storm—pushing the boat backwards into the waves—then at the right moment, jumped in. The engine strained in reverse, slowly pulling the boat back into deeper waters to continue the journey home.

It was a superhuman feat by tough men charged with adrenaline. The fishermen were unusually strong and could move anything if they could just get a good grip with their massive hands. Yet on the waters they scampered about the constantly-moving, tossing hulls with the sure-footed agility of cats.

They lived with pain and discomfort every day. Einar Ekmark even did his own dentistry. He woke up one morning with a terrible toothache. His partner, Carl, said he'd go start up the boat while Einar did what needed to be done. On the kerosene stove, he heated a nail until red hot, then jammed it into the aching tooth. The tooth burst, and Einar picked out the pieces as he walked out to take his place in the boat. He claimed this procedure really didn't hurt that much.

Most fishermen could not swim and refused to learn, believing that even the best swimmer would not survive the cold water for more than ten or fifteen minutes. They didn't wear life preservers for the same reason.

It's hard to imagine the repressed fear that was their constant companion, yet they certainly didn't express fear outwardly. They met each challenge stoically. After the Swedes returned home from near-disaster, having repaired their boat in the storm, my father asked Einar, "How was your day?" Einar answered, nonchalantly, "Oh, so-so."

Waiting

Fishermen could be detained on the lake for several reasons that raised the anxiety level of folks waiting for them at home. Fog was inconvenient, though usually not life-threatening. In heavy fog, the fishermen used "dead reckoning" to guide them to and from their fishing grounds. They knew the compass course and distance from one buoy to the next, and they could calculate how many minutes at what speed it should take to reach each floating landmark. Occasionally, if lost and close to home, the men might be assisted by people on shore who would bang on empty gas barrels with hammers to guide the boats in.

In calm weather, engine trouble resulted only in rowing or being towed in. On the other hand, engine trouble in a storm with high winds could result in the small boats breaking up or swamping.

The fishermen did not have radios, radar, sonar, or other communication or navigational aids. When they were out of sight of other boats, they were alone. With no means for fishermen to communicate their problems, the folks back home were left to their own imaginations—which always considered the worst scenario first. Even with the comforting and encouragement of others, a wife always had the feeling that "this was the time he wouldn't come home." Rescue attempts were out of the question in huge storms, leaving those who waited feeling frustrated and helpless.

But almost always, the tension was broken by someone who heard the engine or spotted the small boat in the distance and shouted, "There they are!" The now-lighthearted group moved to the dock to await the arrival of the late boat and listen to the men's story.

The waiting wife might not join that group. Knowing her husband and hired man would be looking for a hot meal right away, she dried her eyes and hurried off to her kitchen. She'd hear the story over a late supper.

On an ordinary day, it was the children's job to inform Mother when they heard Dad's boat. There were over a dozen boats operating out of Washington Harbor, but all children could easily identify their dad's from the rest. Model-A Ford, Buick, Hupmobile, Red Wing, Palmer, Grey Marine, and Kermath engines, with various reduction gears, mufflers, and exhaust systems, all sounded slightly different. The kids knew whose was whose.

When she heard "Dad's coming, Dad's coming!" she knew she had about 45 minutes to get a hot meal on the table for her cold, tired, and hungry husband.

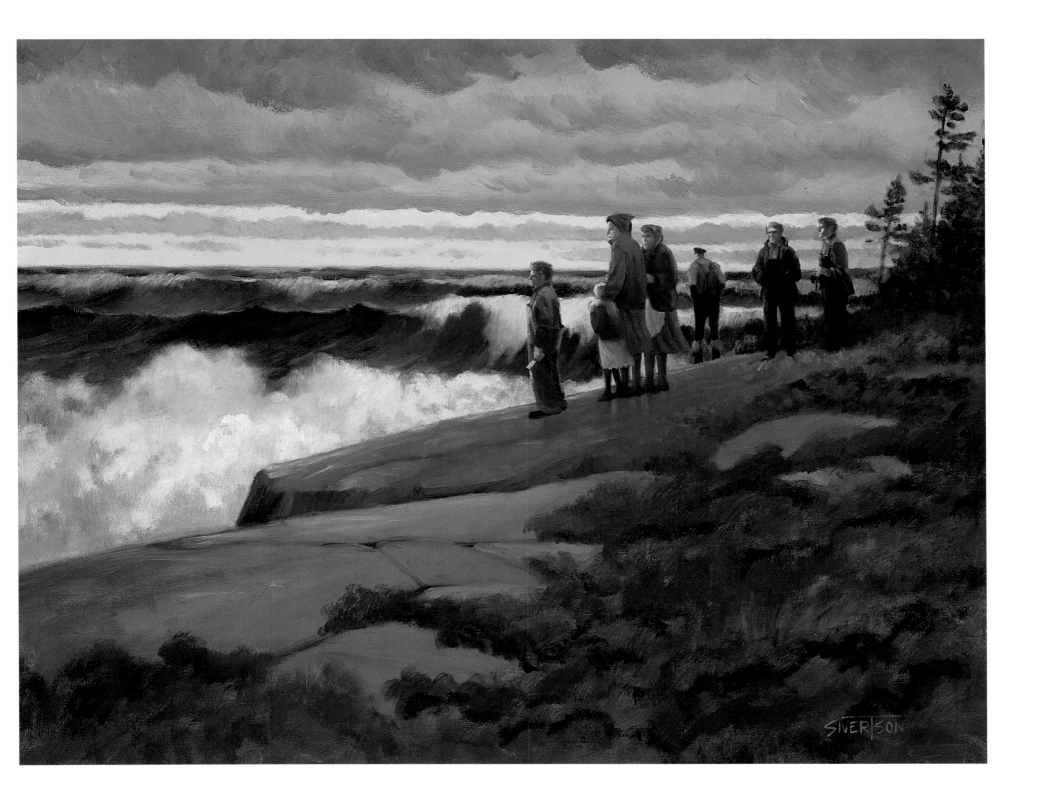

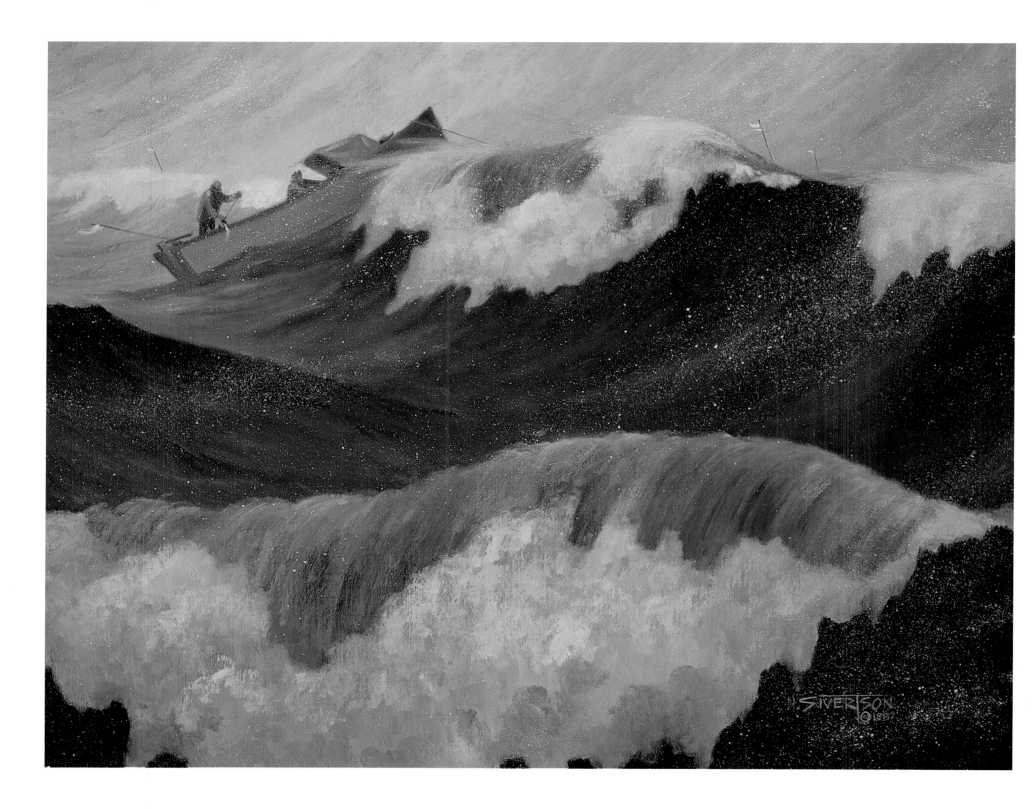

Tied to a Buoy

Late fall storms claimed many large ships on Lake Superior including the famous 729-foot freighter, the *Edmund Fitzgerald*. At Isle Royale, nine large freighters and passenger ships were dashed to pieces in fall gales from the late 1800s to the mid-1900s. Deadly blizzards pushing 30-foot waves were too much for even the largest lake ships, smashing, breaking, and sinking battered hulls, sometimes with all hands on board.

Isle Royale fishermen in 20- to 30-foot open boats were caught by surprise in the same storms that sank the mighty freighters, threatening their lives. Unable to run in any direction, the fishermen's only option was to tie their boat to a net buoy anchored to the lake bottom. The buoy's anchor line was resilient and stretched with the surges of the giant seas, keeping the bow facing into the wind and sea. The spray hood was raised to keep most of the cresting waves from falling into the boat, which had to be pumped constantly.

As gale-force winds drove snow, sleet, and spray over them, the men began to recall disturbing stories of friends found days after a storm, still in their boats, with hands frozen to the oars and feet imbedded in solid ice.

Will the storm worsen? Will the temperature drop? Will the engine start? Can the hull take the beating? Will they find our bodies? Is that farm still for sale in Iowa? These were the questions occupying their minds.

A few didn't make it. Many had close calls, but most survived to start the next-day search for lost nets. Still, the small, wooden, open boats of the fishermen were very seaworthy if handled correctly. If the boats maintained enough headway to keep the bow into the seas, they could ride out most any storm. Engine failure was disastrous because a boat without power would turn broadside to high waves and get swamped in the trough.

Fishermen learned to read weather signs pretty well. Every morning and evening, Dad tapped the glass of his barometer to see which way the needle bounced, indicating high or low pressure on the way. He checked the sky constantly, using cloud formations to predict oncoming weather systems. Each evening, he listened to the radio weather forecasts from the mainland west of Isle Royale.

His whole body was attuned to pressure changes and sensed storms still out of sight. He also read the signs of nature. High-soaring seagulls indicated approaching high winds. Crickets, birds, and frogs all gave their own weather signals to the attentive fisherman.

He and his fellow fishermen avoided heavy weather that moved in slowly. Most life-threatening were the sudden storms that came without warning, building up waves across the expanse of Lake Superior, catching the fishermen with no chance to run for cover.

Wiped Out

Searching for nets lost in devastating fall storms was depressing. As soon as wind and seas subsided, the fishermen went back to their fishing grounds. Where they had set thousands of feet of nets, they now dragged grappling hooks, hoping to snag and recover whatever rigging they could.

They might spend several days trying to retrieve enough to repair and continue fishing. They also didn't want to leave scraps of netting in the lake that would continue to catch and kill fish for no useful purpose.

Because fishermen set their gill nets in shallow, unprotected waters, the giant waves easily picked them up off the lake bottom, rolled them up, tangled them in rocks, or threw them on beaches and even in trees. If a fisherman had all his nets set out and exposed to the storm he would be wiped out financially. The fishermen had no government subsidies, insurance, or bank credit to fall back on. The fish companies in Duluth were their creditors, furnishing the fishermen with all supplies needed during the fishing season, from netting and gasoline to groceries and clothes.

At the end of the season, each fisherman would settle up with the fish companies. They deducted his accumulated bills from the value of the fish shipped. If a fisherman was wiped out by a storm, his reputation as an honest, hard-working man provided creditors with the faith needed to re-outfit a bankrupt operation. With very few exceptions, that faith was always rewarded as the fisherman worked even harder to "clear up" his bill.

My father, Art Sivertson, was wiped out twice in one fall season. Not only his family but the families of his two hired men were affected. The situation was desperate. After working eighteen-hour days for eight months straight, none could even pay their grocery bills for the season.

With tears in their eyes, the big brutes hugged each other and agreed to give it one more try if Dad could finance another rig. They had excellent fishing after closed season re-opened, and luckily broke even.

Hopes for a good year—when fishing was excellent, prices high, and storms few—kept the fishermen coming back every year to "the rock" they loved. They committed their lives to their island homes. The people were strong and enduring and made use of what Isle Royale offered, accepting the island's terms.

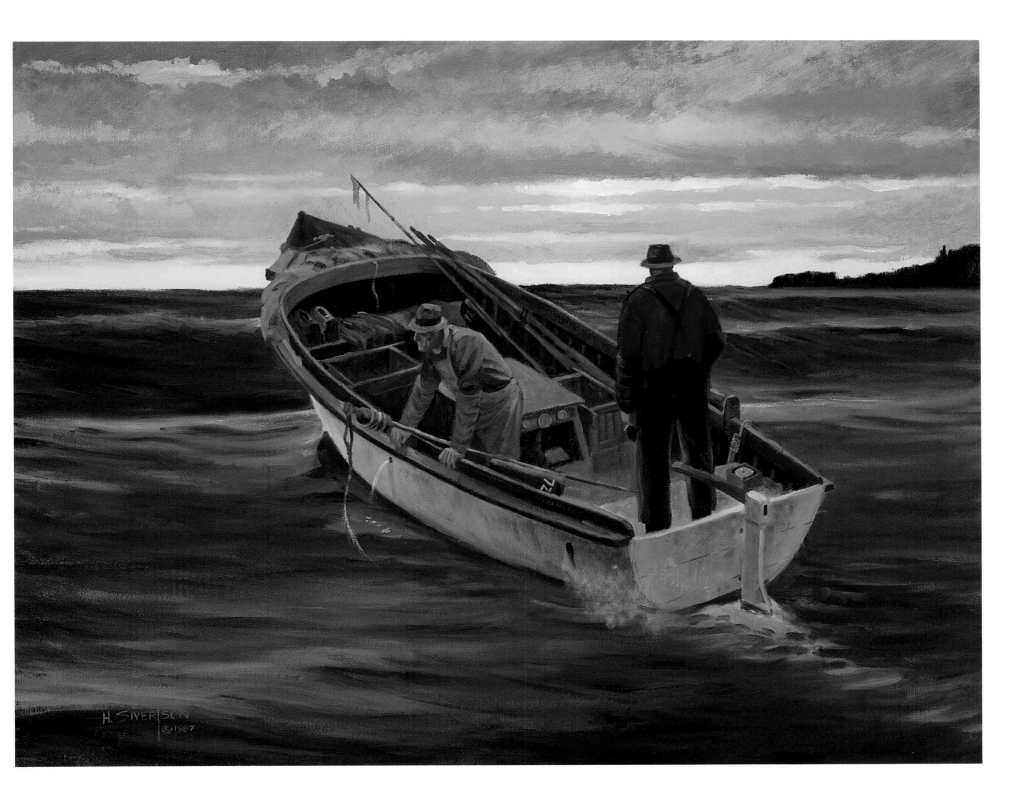

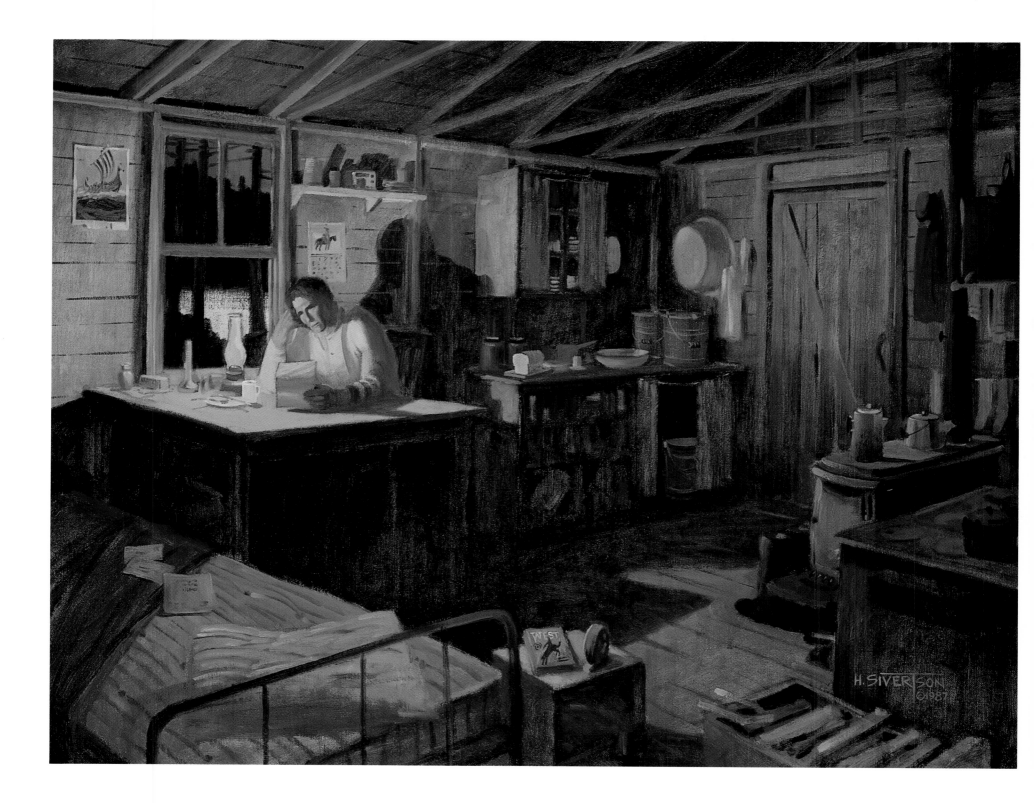

Bachelor's Shack

Many of the Isle Royale fishermen were bachelors. Of these, most worked as hired men, although a few owned their own rigs. Their full days of work left little time for cooking or housekeeping. Those who worked for married men usually took their meals with the family and had their laundry done by the boss's wife. Those who weren't so fortunate had to find time to cook, clean, and do laundry for themselves.

After working sixteen to eighteen hours a day, there just wasn't much time for household duties. Something had to give. They cooked and baked, but housework and laundry were neglected until "storm days" when it was too rough to go on the lake. On the other hand, they didn't change clothes often nor did they spend enough time in the house to create a mess, so a "lick and a promise" on storm days quickly satisfied their standards of cleanliness.

A one- or two-room shack was all that was required for a bachelor's living quarters. A wood heating-stove, kerosene or wood cookstove, a bed or cot, table and chairs, makeshift cupboards, and a gas lantern and kerosene lamp were his comforts of home. If simplicity is the essence of good living, the bachelor fisherman lived best of all.

A bachelor shack is best described by the odors within. As you entered the door, the first smell was his "jack" shirt, hanging on a nail, that he wore while cleaning fish. The shirt also held a hint of gasoline and engine oil. The odor of drying wet boots and wool socks came next, with a suggestion of kitchen slop-bucket mixed in. Aromatic fresh-baked bread and hot coffee blended with smoke from the stove and pine pitch from the woodbox. A little kerosene smoke from the lamp and chewing tobacco from the "spittoon" can on the floor chime in.

And then there's him. He wears two suits of 100% woolen underwear in the spring and fall, but amazingly does not smell of body odor—unless you consider the scent of chewing tobacco or brandy or cigarette smoke as body odors.

The overall fragrance was actually quite pleasant, somewhat like an old wine cask. Today, you need to visit a lumber camp, deer shack, or any similar gathering place for men to experience this wonderful array of odors gained from "real" living.

In the evenings after a long day, the bachelor sometimes wrote letters, perhaps to send home to relatives in Norway or Sweden. More often, he picked up a dime Western novel to take up where he had left off the night before.

For some reason, the fishermen all seemed enthralled with the adventures of the cowboys. The fisherman's own daily life on Lake Superior waters was probably more hair-raising and life-threatening. Yet for some reason he enjoyed reading about cowboys for a few minutes, before hitting the horse-hair mattress for a few winks—until the morning's first glimmer of dawn sent him back on the lake.

Moving Day

Most fishermen worked in teams of two to a boat. Some of these partnerships lasted for years, even a lifetime. Some were together so long their names were run together as if they were one person. Chris Tollefson and Gus Bjorlin became Crisn'gus. Melford and Arnold Johnson were Melfordn'arnold. Carl and Einar Ekmark became Carln'einar and so forth. There were no formal agreements or legal papers that bound the partners together. It was just the way it was. The partners lived and fished from the same location for years.

Sometimes a partnership would break up for a variety of reasons, and a new partner would be sought. If living quarters were lacking, the new man might bring his old house with him or find an unoccupied house and move it to the new location.

If a log house was to be moved, the logs were first numbered. The house was then carefully taken apart, hauled to the new location, and re-assembled.

A frame house was moved intact. The fishermen would skid the house off its foundation to the water, using logs and block and tackle. At the water's edge, empty 54-gallon gas barrels were tied under the house. It was then pulled into the water and towed to the new site with gas boats and skiffs. Then, with block and tackle, powered by boats and men—and maybe a dram or two of whiskey to fuel the men—the house was pulled out of the water and skidded to its new resting place. The whole operation might take half a day.

Even though fishermen competed with each other for fish, they helped each other in times of need. Still, the competition between some fishermen was fierce bordering on cruelty. Enemies engaged in "dirty tricks" against each other for years. Gust Torgerson and my grandfather Sam Sivertson acted like mortal foes, setting nets on top of each other's and cutting anchor lines. They apparently made life miserable for each other.

One year Sam lost all his nets in a net-house fire, bankrupting him. He faced having to quit fishing and leave Isle Royale. That next night under cover of darkness, Gust Torgerson dropped off two brand new nets on Sam's dock and left without a sound.

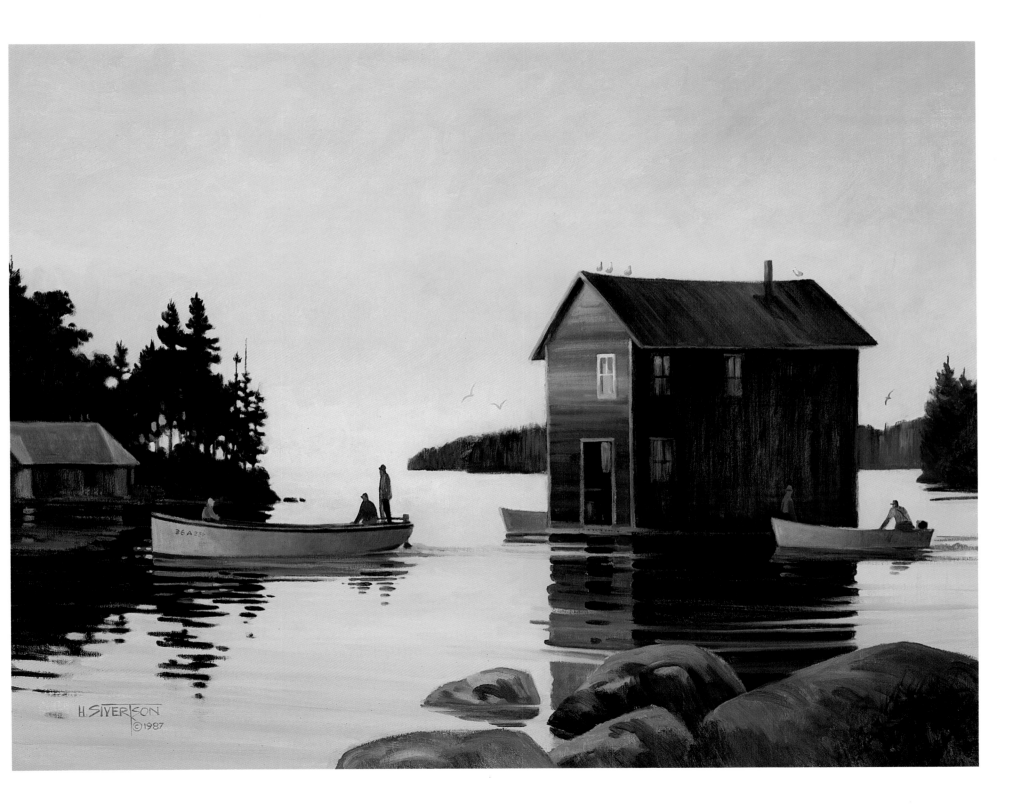

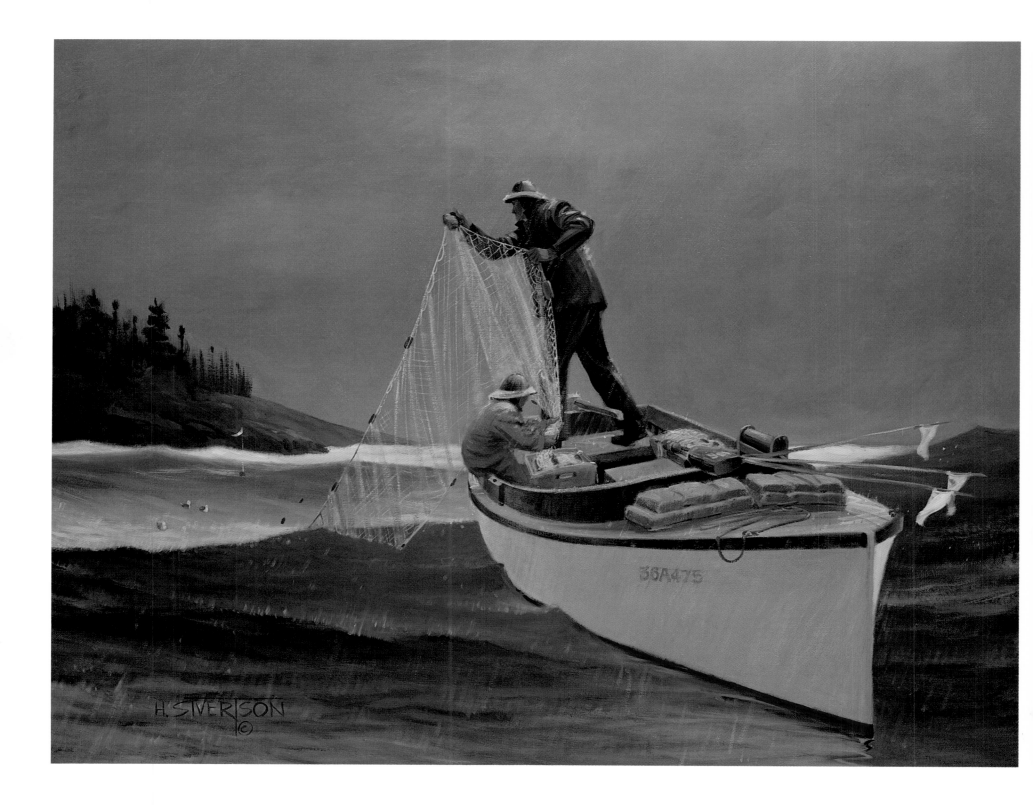

A Family Tradition

My ten- by ten-foot tarpaper shack was midway between the boat dock and the family cabin. A gravel trail from the cabin meandered through woods and along the shore of our small island for about 200 yards before breaking into a clearing on a quiet bay where fish house, dock, net house, and reels were clustered.

The "interpersonal relationship" jargon we hear today didn't exist when I was a child. My father didn't tiptoe into my shack early each morning to gently request that we "spend some quality time together in a meaningful way."

Before dawn, I heard the screen door slam on the family cabin, followed by the sound of heavy boots crunching on gravel, then the thud of my dad's ham-like fist on the side of my shack. I was half-dressed in my cold clothes, still wet from yesterday, by the time he grunted "Let's go!" and crunched on down the path to the fish house and waiting boat.

I was a twelve-year-old "hired man," anxious to prove myself. The greatest trick for me was shuffling down the trail in my hand-me-down boots, much too big for my feet, fast enough to catch up with him before he reached the frost-covered dock.

It was my job to siphon gasoline from a 54-gallon steel barrel into the gas tank of our 24-foot fishing boat. The siphoning process consisted of sticking one end of a six-foot rubber hose into the barrel, sucking on the other end until the gasoline reached my mouth, then quickly thrusting the hose into the boat's tank. It was difficult not to swallow a bit of gasoline. Meanwhile, Dad loaded the boat with nets, boxes, buoys, anchors, and anchor lines, after which we returned to the cabin for breakfast.

Mom filled our lunch boxes with sandwiches, fruit, and dessert while we ate breakfast. She looked inquiringly at me from the kitchen, wondering whether I'd want a lunch today or if I expected to be seasick again. I shrugged my shoulders in response to her sidelong glances as I tried to choke down my breakfast of oatmeal with canned milk, greasy eggs, and coffee, all chewed with a lingering taste of gasoline.

The unmuffled roar of the old Buick engine broke the cold stillness of the harbor as we headed out to the open lake and our fishing grounds, ten to fifteen miles away, into the rising sun.

We would set several gangs of new trout nets before lifting the nets set on our previous trips. My job was to guide the nets to Dad's hands and run the engine. Dad spread the nets before they entered the water while steering with the tiller between his knees, as shown in the painting.

My prospects for developing into a commercial fisherman were few. By ten years of age I'd decided I had reached my limits of incompetence. Besides being prone to seasickness, my dreamy nature and uncoordinated body made me a dangerous fishing partner. Total concentration and split-second reaction time were basic requirements needed to get the work done and stay alive on the lake.

In spite of my incompetence, and the occasional pain and discomfort which were part of the commercial fishing tradition, the sense of purpose, belonging, adventure, and excitement made growing up on Isle Royale a wonderful experience.

Caught Inside the Breakers

It was an unnaturally beautiful day in August. Dad and I were setting nets on McCormick's Reef, fifteen miles from home. We were shirtless, and chatted good-naturedly while enjoying the relaxing, warm, sunny, dead-calm day.

Engrossed in our work, we didn't notice the gently increasing swells from the south sneaking along under the calm, hot air. The last of our nets had just disappeared over the side, and as Dad reached for the buoy all hell broke loose. In almost the instant it took to throw the buoy overboard, gale-force winds and mountainous seas hit us so hard it was almost impossible to turn the boat into the wind toward home. This was no ordinary squall but one of those freak storms, the type that surprises and sinks freighters.

Progress was extremely slow. Huge waves broke over the bow with sickening regularity, dumping more water into the boat than the self-bailer and Dad on the hand pump could handle. I sat tight to the stern seat with a death grip on the tiller, steering directly into one wall of water after another.

Dad spotted Carl Ekmark alone in his boat and in obvious trouble. He had no choice but to try to help. I maneuvered our boat as close to Carl's as safety permitted, and at the only instant possible, Dad made a giant leap across six feet of hissing sea and landed safely on top of Carl in his boat. He shouted for me to "Stay in deep water—outside the reefs!" as I struggled on, alone.

I didn't realize the wisdom of those words until too late. In my fear, my instinct was to stay close to shore. Just minutes after leaving Dad behind in Carl's boat, I became aware that I had allowed the boat to get inside the reefs.

As the waves hit the shallow water, they turned into tall breakers that threatened to swamp my boat. In sharp configurations, twenty-foot waves became perpendicular walls, and they started dumping their foamy crests in on me.

After an endless time, I managed to steer the boat into deeper water. Here the waves, though still as big, were more like rolling hills. The boat was awash with water, floor boards were floating, and the engine was very close to drowning out. A couple more of those breakers would have ended my twelve-year-old life.

After ten miles of riding the roller-coaster seas, I rounded the last point and headed into Washington Harbor. The bilge pump finally emptied the water from the boat, the floor boards settled down, and the engine was still running. As the storm subsided, the wind switched to a gentle offshore breeze, bringing the smell of flowers—twin bells and beach roses—to calm my upset nerves.

I pulled myself to the normal steering position, standing tall with the tiller between my shaky knees, and cruised with an air of nonchalance to the fish-house dock. No one greeted me on my triumphant arrival. I knew it wasn't manly to brag about my heroic adventure, but I hoped someone would have been there to worm it out of me.

I swaggered the 200 yards up the path to the screen door of the house and announced to my mother, in my deepest voice, that "Dad will be along a little later." "That's nice," she said. "Now go along and play until supper."

I waited on the dock for Dad and Carl, who arrived shortly after. Certainly there would be some back-slapping, hand-shaking, some show of camaraderie to celebrate our victorious return. "Kind of rough, huh?" Dad said, and that was it. No more. But it was said with a new respect.

As I was now much too old to "Go play," I helped with shore work until supper time.

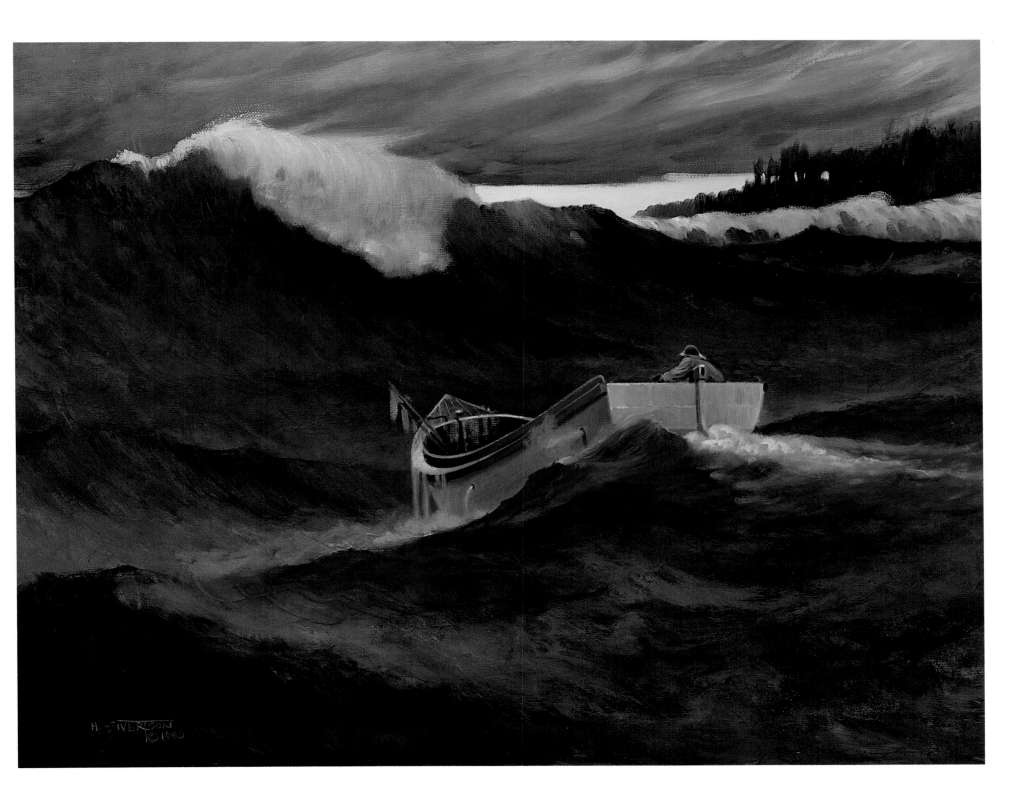

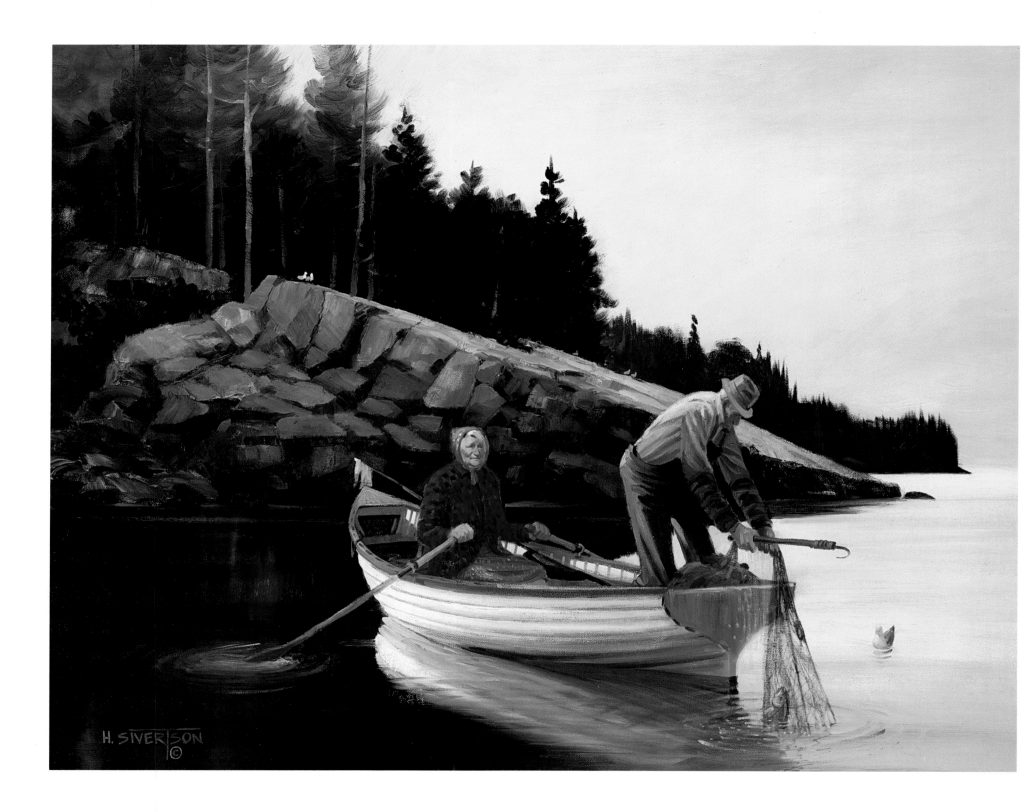

Retirement

Sam and Dora Sivertson settled in Washington Harbor on Isle Royale in 1892. They raised four children who continued the family tradition of commercial fishing. Then, later in life, my grandparents "sort of" retired. Their son Stanley and two hired men continued fishing Sam's rig, allowing Sam and Dora to "take it easier."

No longer did Sam have to make the long run to distant fishing grounds on the open lake in a Mackinaw schooner or gas boat. But he continued to fish "beach nets" in sheltered coves close to home, using a 16-foot rowboat, a few trout nets, and Grandma.

T'dora—as Sam called her—rowed him several miles to his nets each day. Sam kneeled and sometimes stood on the narrow back seat of the rowboat, lifting and setting nets. In his Norwegian accent, he grunted commands past the stem of his pipe to T'dora at the oars. "Rew up" (row against the wind or current), "Rew down" (row with the wind and current), "Steady," and "Go ahead and rew backwards" were executed without a complaint by the strong woman with the straight back at the oars.

After a couple of hours of lifting, picking a few trout, and resetting the nets, Sam sat down on the stern seat and motioned towards home, pointing the direction with his pipe stem. T'dora's strong arms snapped off the strokes as she rowed towards a target she didn't bother to turn to look at. Instead, she lined up Sam's head with another object directly astern and held that course, until Sam signaled another course change with the stem of his pipe.

So they continued until reaching the dock, when T'dora finally turned to see where she was going so she could land the boat. We kids would often be there to meet them, to see what they had caught. Sam waited until the moment the rowboat touched the dock, and then broke the silence with "Vere's lunch?" My usually patient, understanding, loving Grandmother always answered with a flurry of words, in Norwegian that I couldn't understand.

They didn't really retire, but just slowed down some. Besides fishing a few nets, Grandpa mended nets and did other shore work, but found plenty of time to sit in his chair and smoke a pipe. Grandma continued to cook, bake, clean house, do laundry, and fuss over her flowers. The coffee pot was always on, ready to serve the frequent visitors. I remember her especially as the quiet strong center of things, an unobtrusive core of love that everything else seemed to move around.

Grandma Seeks Fortune

It all started on a stormy Monday, October 28, 1895, when the 360-foot bulk-cargo freighter *Centurion* ran aground at Siskiwit Bay on Isle Royale.

Eastbound from Superior, she sought shelter from a northwest gale and blinding snowstorm behind the island windbreak. With waves breaking over the pilot-house and snow obscuring her vision, the *Centurion* ran hard and fast on one of the reefs guarding the entrance to Siskiwit Bay. After the storm, with the help of island fishermen, she had to jettison her cargo of 600 tons of copper ingots and 27,000 sacks and barrels of flour. This lightened her hull enough to allow the steamer *Penobscot* eventually to pull her free.

For their part in the rescue, island fishermen were allowed all the flour they could retrieve from the lake, free. Some thought the flour would be soaked through and useless, but to the contrary, the water penetrated just a fraction of an inch to mix with the flour, forming a waterproof seal that protected the rest.

Sam Sivertson loaded his Mackinaw boat to the gunwales and sailed the load 20 miles back to Washington Harbor, not sure what he would do with his hoard of free flour. If stored properly,

it might last for a few seasons. Several other Washington Harbor boats had also helped in the salvage and had the same problem. What to do with all that flour?

Dora Sivertson, bless her heart, offered to bake bread rolls and biscuits for Washington Harbor fishermen for a fee. For each 100-pound sack of flour she baked, she charged only 50 cents. Needless to say, she and her wood cookstove were busy for a long time. She finally got wise and announced she had to raise her prices... to 75 cents.

I always thought instead she should have formed a salvage company and retrieved the copper ingots—worth considerably more—but the Inman Tug Company beat her to it.

More than 25 ships ran into the reefs of Isle Royale and more than half are still there on the bottom. Besides aiding in salvage operations after a disaster, Isle Royale fishermen often rendered assistance to help numerous ships avoid the treacherous rocks and reefs that surround the island, saving many lives.

The *Centurion* had a long and useful life after her Isle Royale encounter and managed to stay afloat until 1945 when, as the *Alex B. Urig*, she was scrapped.

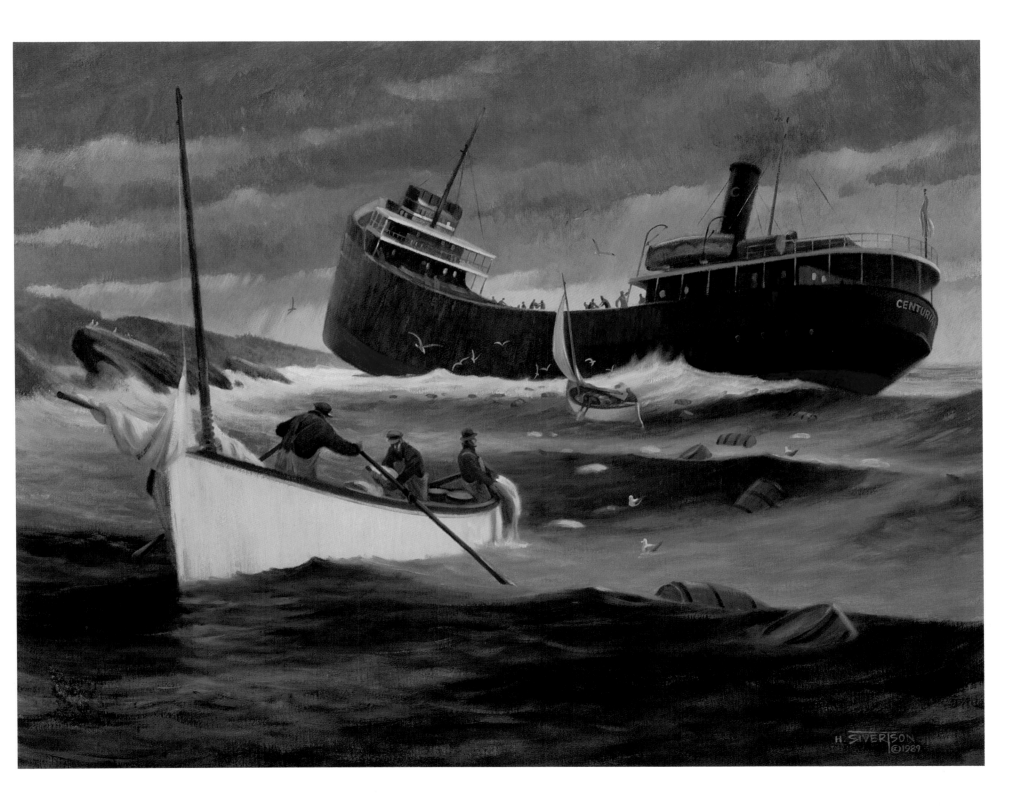

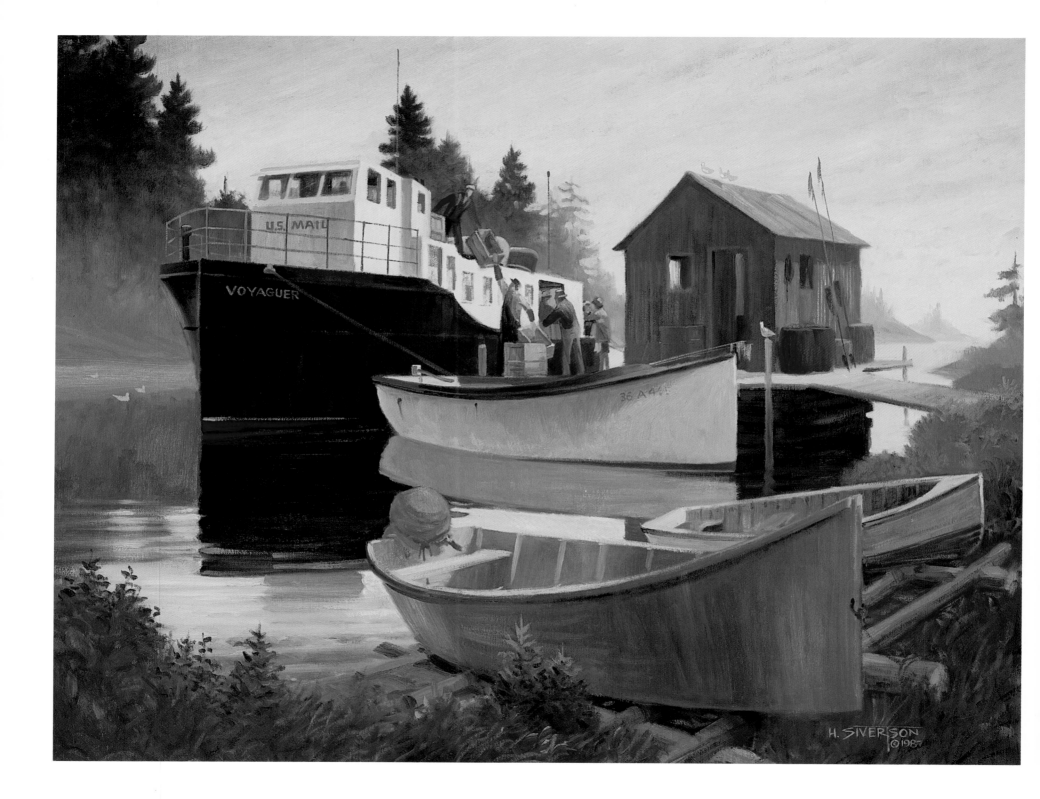

U.S. MAIL

VOYAGUER

36 A 44

H. SIVERSON
© 1987

New "Boat Day"

Significant national events occurring in the 1930s and early '40s caused a change in boat service to Isle Royale. With construction of new roads and faster automobiles, motoring competed with the lake's passenger ships for vacation dollars. When the Depression hit, the price of fish dropped considerably, making it less profitable for the large steamships to operate. Hard times also took a toll on Isle Royale summer tourism.

In 1942, fishermen Arthur and Stanley Sivertson established the Sivertson Brothers Fishery, and started running a succession of boats smaller than the old steamships. Starting with the 35-foot *Rita Marie* in 1942, they soon replaced her with the 36-foot *Disturbance* from 1945 to 1954. She was followed by the 48-foot *Voyageur* from 1955 to 1971 and, after 1972, by today's 63-foot *Voyageur II*.

Similarly, in 1944 the competing firm of H. Christiansen and Sons replaced the large 119-foot *Winyah* with the 65-foot *Detroit*, nicknamed the "pickle boat," which ran until 1951.

The smaller boats of that era were more economical than the obsolete steamships. With their smaller size and better maneuverability, they landed at each fisherman's dock, giving individualized service. It was more convenient for the fishermen, but the social gathering and festive nature of the traditional "Boat Day" as a big event was over.

Instead, each family celebrated the occasion by themselves. Grocery and supply orders were given to Roy Oberg, the captain of the Sivertson Brothers' boats for 50 years. News and mail were exchanged. Groceries, gasoline, empty boxes, and ice were off-loaded, and fish loaded on. The event was over in just moments, as the boat left for the next dock and so on around the island.

In the early years of the *Disturbance*, there were no special accommodations for passengers. Most passengers were friends or relatives of fishermen and everyone rode free. The only seating was on ice and fish boxes covered with canvas tarps. To pass the time, Captain Oberg or Mate Merl Otto might join the passengers in a game of cribbage or poker.

Captain Roy Oberg is a legend in his own time with a record of over 3,000 trips around Isle Royale in 50 years without one accident. Most of those trips he navigated the treacherous waters in all kinds of weather. In dense fog, heavy winds, and blizzards, he used only a compass and watch and his finely-tuned senses. Roy could determine his position in fog anywhere around the island by smells and sounds. The odors from balsam, cedar, twin-bell, or guano-covered rocks, and the sounds of seagulls or waves on beaches, all helped guide Roy around one of the most challenging mail routes in the world.

Poached Moose

The moose population flourished in the 1930s and '40s to the extent that it overran the island, which was too small to support the rapidly growing herd. Game wardens in the 1930s trapped and kept moose in corrals for shipment back to the mainland, to keep them from overbrowsing and dying for lack of food. Nevertheless, it was against the law to shoot moose on Isle Royale.

But the fishing families wanted red meat in the fall. During the closed season of October, when no fish were shipped, the freight boats that brought fresh meat and groceries to Isle Royale ran infrequently. Soon tired of a diet of ham and fish, the islanders began to crave fresh meat.

Each fall, Washington Harbor fishermen hunted or poached a moose or two and shared the meat with their neighbors. Though there was only one game warden to police the entire island, the men hunted with caution. The warden knew the fishermen were taking moose, and the fishermen knew the game warden knew.

The unwritten law was not to dangle the evidence in front of the warden, forcing him to do his duty. Moose meat was hidden from view, buried in ice houses. Skins were filled with rocks and sunk in the lake. Bones were buried. Guns were kept out of sight.

What the fishermen weren't aware of was that the game warden also shot a moose now and then. He also tired of fish and ham and had the same craving for red meat.

One October day, on one of those annual hunts, a party of fishermen from Washington Harbor heard two shots not far away. They carefully stashed their own guns, went to investigate, and found the warden bending over a dead bull moose. The cow was in a similar state, lying not far away. The startled game warden looked up and without hesitation offered the fishermen the bull. "The cow will be plenty for me," he said.

Until the National Park Service took over, Isle Royale was under the jurisdiction of the State of Michigan. Fishing and hunting regulations were set by officials who in many cases lived quite far away in the lower peninsula of Michigan. Sometimes these rules just didn't make much sense to the island natives. Living on an isolated island with a moose population wildly out of control, the people on Isle Royale viewed the ban on hunting moose to be meant for those who killed for sport and antlers. The fishermen killed only on rare occasions, and only for meat... and so did the game warden.

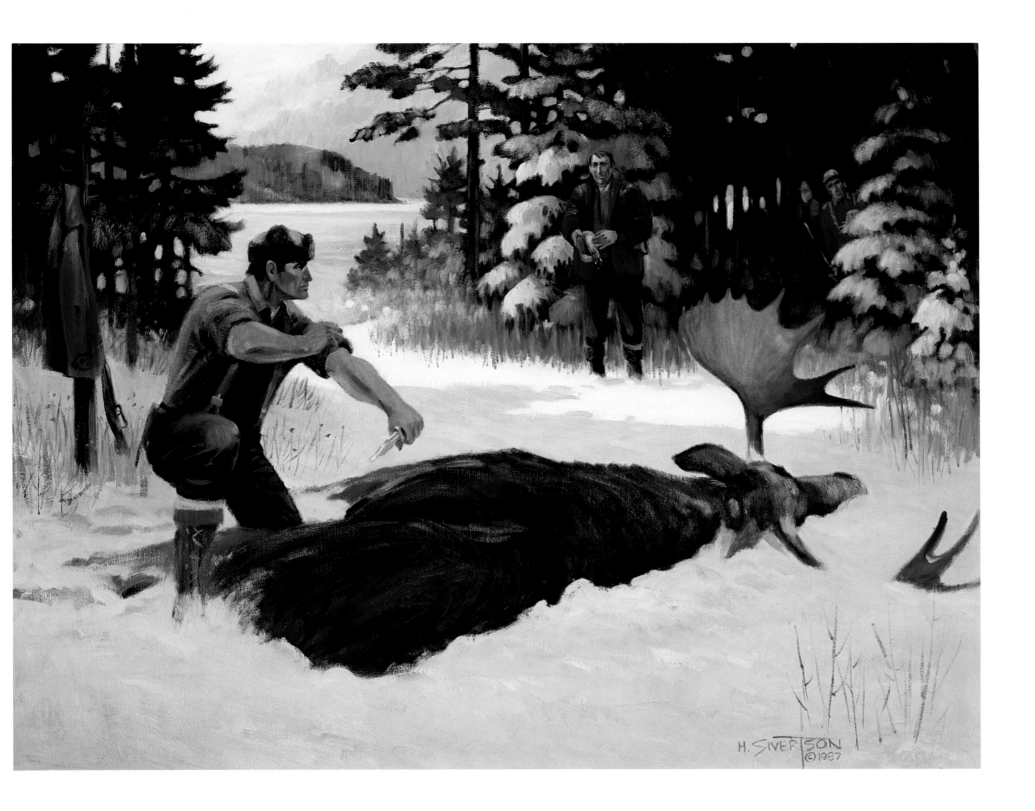
H. Sivertson
©1987

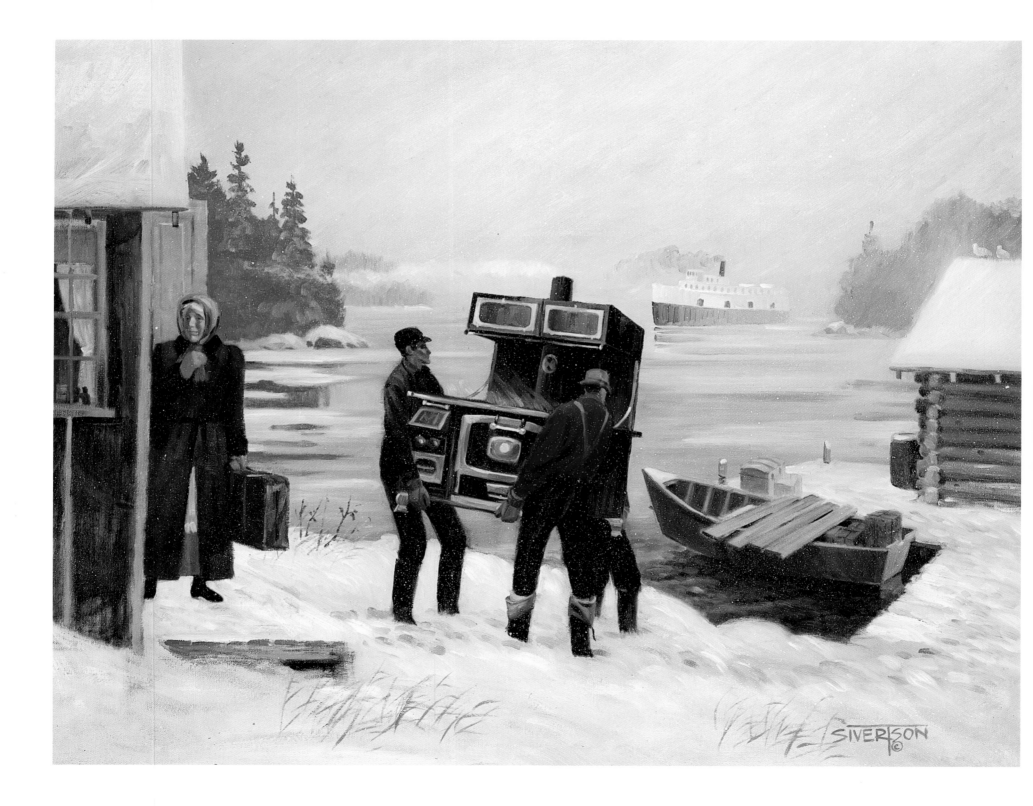

December Departure

They huddled in their cabin around the cookstove, trying to keep warm. It was December, and the *America* was three weeks late. The family was down to their last five pounds of flour. If the *America* didn't come soon, it spelled disaster for the last family left that winter on the island.

My father often told this story from his boyhood. According to the message from the captain of the *America*, the steamship was to have picked them up three weeks ago. Every moment of that anxious period was spent by the whole family—waiting by the stove. All their clothes and possessions were packed. They could not leave their post and risk missing the sound of the steam-whistle announcing the boat's arrival. When they heard the whistle, they had only 45 minutes to gather their belongings, load the skiff, and rendezvous with the boat in the harbor.

With no communications, the Sivertson family was left to wonder about the fate of the boat. Did the *America* sink? Engine trouble? Lost? Or did the captain forget about his promise to pick them up?

In pondering the thought of trying to survive on Isle Royale through the winter, without food, I'm sure they thought of Angelique and Charlie Mott's gruesome experience in 1845. They were abandoned on Isle Royale without food when the owner of the schooner *Algonquin*, Mr. Mendenhall, didn't fulfill his promise to send his ship with supplies. Charlie starved to death but

Angelique stayed alive by trapping rabbits using snares fashioned from her own hair.

It was possible for a family to survive a winter on the island if preparations were made far in advance of the last trip of the supply boat. During the Depression years, a few families decided to winter over on the island because they couldn't afford renting a winter home in Two Harbors or Duluth. Cows and pigs were raised, vegetable gardens planted, food canned, and supplies ordered and stocked to carry them through the long winter.

Those winters, the families hunted moose, trapped coyotes, fished through the ice, and cut lots of firewood. They rowed boats or snowshoed ten to fifteen miles on holidays to visit with neighbors in other harbors. John Skadberg's family from Hay Bay, Holgar Johnson's from Chippewa Harbor, Pete Edisen's and Melford and Arnold Johnson's from Rock Harbor, all survived winters on Isle Royale.

The *America's* whistle finally blew. Bread was quickly taken from the oven and wrapped in paper. The glowing coals were dumped into the snow and the still-hot stove carried off with other belongings to meet the long-lost *America* for the trip back to the mainland. It seems the missing boat had been to Ontario with a load of moose hunters who chartered her for a couple weeks with a last-minute offer the owner couldn't refuse.

Exiled

This picture depicts the burning of my father's homestead in 1957, a sad day for our family. All around the island this scene was repeated as Isle Royale was transformed in the 1940s and 1950s into a National Park.

Though the families of Isle Royale had been good stewards for 100 years, the Park Service was eager to turn the island into a pristine wilderness—with as little trace of humans as possible.

While life-long leases to stay on the island were granted to property owners and their children, this did not involve the fishing families. Most of the fishing families were squatters. Of all the fishermen on the Isle Royale, only two to my knowledge owned their land. In the case of the Sivertson family, we had lived on the island for three generations without concern for legal title.

The arrangement offered the fishing families was that they could receive special-use permits annually to live on the island and fish. However, if they missed any single year, they risked forfeiting their rights to a permit—and to their island homes.

The knock-out blow was dealt by the invasions of two predator populations: the smelt and the lamprey. Introduced in 1930 as an experiment by a government agency, the smelt quickly spread and got out of hand, gorging on trout eggs, fry, and fingerlings. Even more deadly, the lamprey eel first appeared in the late 1940s, literally sucking the blood from breeding-size trout, wiping out the trout population. By 1961, the commercial fishing season for lake trout was closed permanently.

Without lake trout, island fishermen could no longer earn a living. Some tough old fishermen clung to their homes, fishing a little herring to supplement Social Security. Youngsters had little choice but to give up their heritage and homes to find work on the mainland. Once they left, their homes were burned and bulldozed. Despite roots far back in time, a precious island fishing culture quickly vanished.

In place of the dwellings of the fisher folk rose the modern structures of the Park Service. Kerosene lamps were replaced by generator-powered electric lights. Wooden fishing boats were replaced by fiberglass speedboats. The families who had lived on Isle Royale in close harmony with their surroundings were replaced by itinerant Park Service employees who often came and left in a matter of a few years.

In recent years, Park Service attitudes have changed considerably. Park superintendents have shown a commitment to cultural interpretation, opening the reconstructed Pete Edisen fishery at Rock Harbor to display the lifestyle and methods used in island fishing during the 1930s, 1940s, and 1950s. As the first summer demonstrator at the Edisen fishery in 1990, I was impressed that the majority of park visitors showed keen interest in the history of people on the island.

Ironically for the old fishermen, Lake Superior fish populations are now healthier than they were before the lamprey and smelt invasions. Lake trout and other species have made dramatic comebacks. On the island, moose, wolf, fox, and other animals thrive. But the fishing families are gone forever.

As I look back on my boyhood, I see in the lives of the island fishing families a unique way of living—a place where humans and wilderness were not separate, but accepted each other.

In just a few years, the last of the Isle Royale fishermen will be extinct.

Hopefully, they'll not be forgotten.

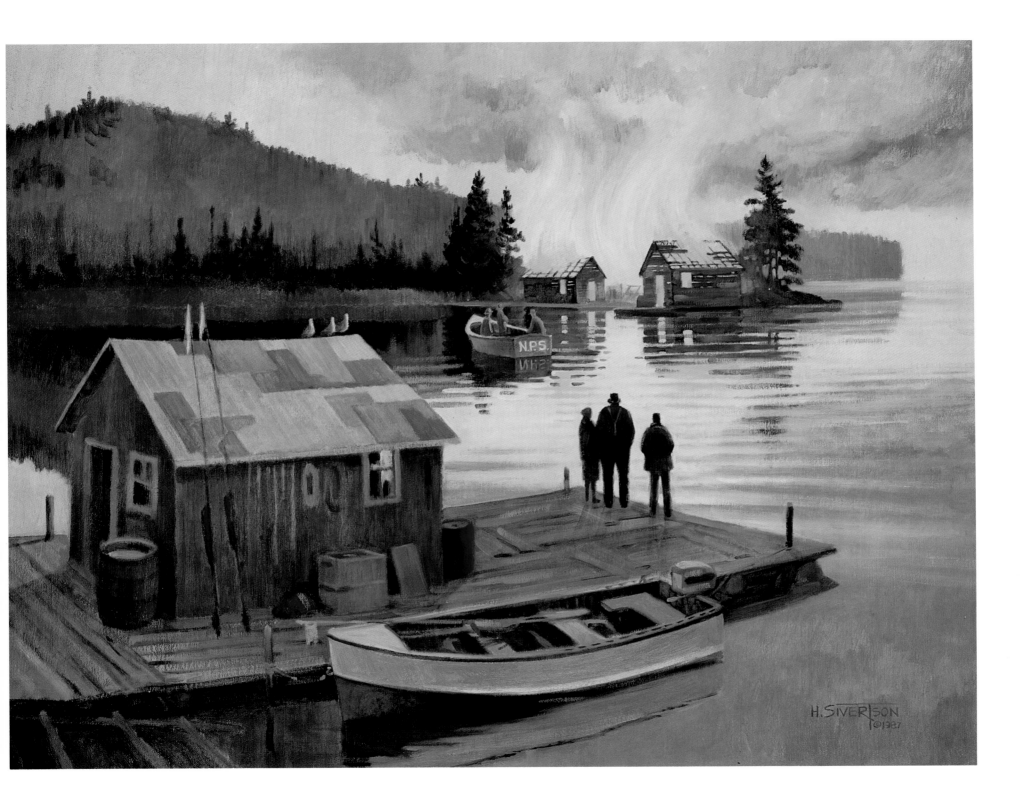

Epilogue

This book tells how a small community of people, isolated on an island wilderness, lived and worked together in competition and cooperation, while existing in harmony with nature. They were independent, resourceful, self-reliant, hard-working people dedicated to harvesting the fish of Isle Royale waters for America's tables. They lived, loved, laughed, and governed themselves with little help or intervention from government agencies. For over 100 years they kept Isle Royale pristine. Their homes and fish houses, made of natural materials, were tucked into and blended in with the rocks and woods along the island edges.

They lived simply on modest incomes. But their lives were rich with experience and surrounded by beauty.

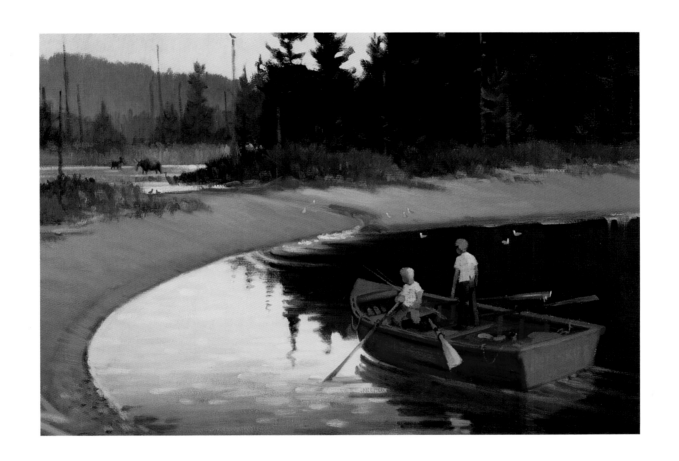

Special Dedication

This book is specially dedicated to the memory of the long-time commercial fishermen of Isle Royale who had their homes on the island during the period shown in *Once Upon An Isle*.

Anderson, Andrew
Anderson, Emil
Anderson, Emil and Elna
Anderson, Edward
Anderson, Gil
Anderson, Sivert
Bangsund, Bill and Isabel
Bangsund, Jack
Benson, Ben
Bjorlin, Gustave
Bjorvek, Albert
Brunvall, Olaf and Ogie
Bugge, Lawrence and Melvin
Eckel, Richard
Eckel, Thomas Sr. and Bertha and Linnea
Eckel, Thomas Jr. and Carol
Ekmark, Carl and Margaret
Ekmark, Einar
Edisen, Peter and Laura
Ellingson, Emil
Erickson, Jens
Francis, William
Gill, Aaron and Theodore
Gilbertson, Carl
Gilbertson, Eric and Hedvig
Hanson, Andrew and Mary
Holte, Ed and Ingeborg
Johns, Edgar and William

Johns, John
Johnson, Arnold and Olga
Johnson, Frank and Sue
Johnson, Holgar and Lucille
Johnson, John
Johnson, Milford Sr. and Myrtle
Johnson, Milford Jr. and Monica
Johnson, Mike and Nellie
Johnson, Sam and Carrie
Johnson, Steve and Myrtle
Kluck, Lawrence and Leo
Kvalvick, Edward and Lillian
Leonard, Gilbert and Charlotte
Lind, Nels
Linklater, Jack and Tchi-ki-wis
Loining, Rasmus
Martin, Berger and Ranghild
Martin, Magnus and Alma
Mattson, Arthur and Inez
Mattson, Louis Sr.
Mattson, Louis Jr.
Mattson, Milton
Miller, John and Genevieve
Mindestrom, Hans
Nicolaison, Bert and Helga
Oberg, Axel
Olson, Charlie
Olson, Otto
Ojard, Kenneth
Parker, Charles and Clara
Pedersen, Hans
Phillips, Marvin and Esther
Purdy, Charles and Alice
Rasmussen, Lester and Edith
Ronning, Chris and Olaf
Rude, Andrew and Andrea
Rude, Sam and Elaine
Samskar, John and Victor

Sawyer, George Washington
Scotland, Conrad
Seglem, Engvald
Sivertson, Andrew and Sophie
Sivertson, Arthur and Myrtle
Sivertson, Severin and Theodora
Sivertson, Stanley and Clara
Skadberg, John A. and Ollie
Skadberg, John T. and Florence
Skadberg, Gene
Swanson, Charlie
Tollefson, Christ
Torgerson, George and Herbert
Torgerson, Gust and Hanna
Wick, Nels
Williamson, William and Christine

And to the sons and daughters who lost their island homes in the process of making Isle Royale into a National Park.

Anderson, James
Anderson, Mary
Bangsund, Bill Jr.
Bangsund, Donna
Bangsund, James
Bangsund, John
Eckel, Richard
Eckel, Thomas Jr.
Eckel, Patricia
Ekmark, Carol
Ekmark, Charles
Ekmark, David
Ekmark, Judy
Ekmark, Lawrence

Holte, Karen
Johnson, Arthur
Johnson, Charlotte
Johnson, Frank
Johnson, Gerald
Johnson, Kenneth
Johnson, Kenyon
Johnson, Holgar Jr.
Johnson, Lois
Johnson, Mary
Johnson, Milford Jr.
Johnson, Nancy
Johnson, Norman
Johnson, Robert
Johnson, Violet
Johnson, Vivian
Kvalvick, Ed
Mattson, Lorraine
Mattson, Louie
Miller (Kempher), Dwight
Miller (Kempher), Darrell
Miller (Kempher), Terrance
Nicolaison, Dennis
Nicolaison, Judy
Purdy, Karen
Rude, Mark
Sivertson, Betty
Sivertson, Charlene
Sivertson, Howard
Sivertson, Sandra
Sivertson, Stuart
Skadberg, Gene
Skadberg, Joanne
Skadberg, Sue
Torgerson, Herbert
Williamson, William Jr.
Williamson, Florence

Afterword

by Timothy Cochrane

Once when explaining navigating a boat in a fog, Howard "Bud" Sivertson animatedly responded, "...there is a difference between being lost and not knowing where you are." Perhaps seeing the puzzled look on my face, Howard added, "You always had the Island." Howard's statement expresses something of Island fishermen's extraordinary sense of the Island and their intricate knowledge of the lake. To get home in spring fog, they knew they had to be alert and calm, and use navigational techniques taught to them by their fathers. Subtle clues such as wave direction, water color, visible underwater topography, shore sounds, and even the fragrance of plant life helped fishermen sense the invisible Island and navigate back to safe harbors. Always the presence of the Island loomed, even when unseen. The fishermen understood the lake and respected its powers; they knew how to "run on the lake" and when

They realized their way of life was distinctive and directly linked to nature in ways most of us could barely comprehend.

it was time to get off the rough water.

Meant as a simple answer to a perpetual boating predicament, Howard's statement is also revealing commentary about him. Isle Royale is a geographical given for Bud. He has "always had the Island." No matter where he is, whether on the mainland or navigating through the archipelago's water, he has the geographical anchor of Isle Royale. It is part of who he is, his center, and he understands this.

Other fishermen made similar, provocative comments. Like Bud, they always had the Island. Profoundly attached to the Island, comfortable with themselves, and inquisitive about people and wild things, they knew Isle Royale waters, harbors, and customs. Even in the twilight of Island fishing, they realized their way of life was distinctive and directly linked to nature in ways most of us could barely comprehend. On the Island, a true maritime culture flourished undiluted by cars, towns, or most mainland social and economic opportunities. Their fisheries were tucked away in sheltered waters and even their habitations blended into the landscape.

Bud Sivertson lived the life he is depicting. In this traditional world, fishermen's

sons grew up wanting to be fishermen or ship captains. Few aspired to be artists! But Bud reminds us that fishing, like painting, is an imaginative act. Fishing marries the imagination—where the unseen fish are—with the hard-boiled experience of practiced technique. Bud also applies another fishing trait in his art: an alertness to subtle natural phenomena which might help improve his "catch"—his detailed paintings and stories. He remembers the tinkling sound of "night ice" breaking apart with morning boats and has the documentary skills to bring the remembrance to life.

Perhaps this is a perverse thing for a friend to admit, but I'm glad Bud was a clumsy teenager in a boat, that he got routinely seasick as a kid. I'm glad for whatever reasons it took for Bud to "start his tape rolling," mentally recording a traditional way of life on Isle Royale in the '30s and '40s.

Meeting Bud and other fishermen intrigued me and made me rethink what is fundamental to Isle Royale. As a Park Service back-country ranger from 1976 to 1979, well-versed in Island wilderness values, I bumped into fisher people who

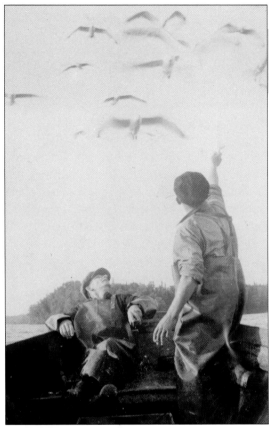

Howard's father, Art, coaxes seagulls to eat from his hand in the gas boat Bud.

precious and precarious part of the spirit of Isle Royale—its fishing heritage. The eloquence of this book of his comes from many hours of thought, study, care, and mistakes. As a former historian for Isle Royale, I know that no other work captures the spirit of Isle Royale more completely, provocatively, or authentically.

Bud Sivertson is a storyteller, funny and passionate about the Island. He is a gifted teacher, even if he might deny it. He is also stubborn, as this work attests. Troubled by the passing of a unique culture, angered by its easy misinterpretation, he is committed to straightening the record. He questions why this should be a twilight period for a nearly vanished way of life.

Bud provides us with detailed paintings of scenes rarely documented, scenes that enrich what we know about living and fishing on Isle Royale. Once skeptical of some of the action depicted, I received my own comeuppance. In the National Park archives, I saw a photograph of two fishermen slapping paint on their gas boat upon their early spring arrival—remarkably similar to Bud's painting of the same task being done by his father. Since Bud could not likely have seen the photograph, it confirmed his uncanny

ability to remember and depict long-ago events faithfully. Further, Bud has captured the emotions of fishing. In the painting titled "Refuge," he knows it takes a few moments, as your racing heartbeat slows down, before the feeling of safety sinks in enough so you can be outwardly appreciative of a rocky spit providing shelter.

As a narrative painter, Bud also seeks to portray the atypical, dramatic moments. Tranquil lunch breaks, Fourth of July ball games, and planked fish are exceptional moments to a steady diet of hard work. Some images appear extraordinary because they stem from a child's perspective. His paintings of fishermen, standing tall on the back seat of a gas boat and steering with the tiller between the knees, emphasize the daily heroism of fishermen—seen through the eyes of a youngster.

In telling or painting a story, Bud mixes the dramatic and exceptional with the

I instinctively felt were part of the Island. Wilderness philosophy told me they weren't supposed to be there, but their sensitivity and devotion to the Island were unmistakable. To learn more about the Island fishing culture, I interviewed Bud and others a dozen years ago, asking questions about traditional life and a "sense of place." These questions eventually led me back to school to get a doctoral degree as a folklorist.

During this time, Bud the "informant" became a close friend. We shared similar goals to document and understand a

Howard, in his studio at Grand Marais, 1992.

necessary realism of how things were. Bud's paintings show identifiable locations, events, equipment, and even wallpaper in fishermen's homes. The various types of boats are lovingly and accurately portrayed. Typical scenes are interspersed with others less ordinary. Yet even his selection of atypical moments—breaks in the flow of daily life—reflects community values. He is remembering the exceptional times which encapsulate and recapitulate fishing values for others to view.

Documentation of the past is only one of Bud Sivertson's aims. The past is alive for Bud. For him, this work is his intimate conversation with bygone days, people, and technology. With his art and stories he compares the past with the present. His beloved gas boats—simple, yet reliable—contrast with the high-tech fiberglass boats of today. The sense of community, of fishermen seining herring at Grace Harbor, starkly contrasts with the pervasive individualism

of today's Island backpacker.

Rich with implicit comparisons, Bud's paintings, even in such an exotic locale as Isle Royale, compel us to think about what we have lost and gained through time. He does not easily accept the notion that the passage of time equals progress. He is most interested in a quality of life. He suggests that "progress" can be blind to more cherished qualities of life: family, sense of place, independence and community, and folk stewardship of unsullied resources.

This work is especially timely as 1992 marks the 100th year of the Sivertson family's presence on Isle Royale. The only fisherman still permitted to fish on the Island is Stan Sivertson, Bud's uncle. Like a handful of other families, the Sivertson family is synonymous with Island fishing. Fishing flows in Sivertson family blood. And as shown in the painting of Sam and T'dora "beach-fishing" from a rowboat, with Grandma providing the power, fishing embraces both male and female family members. This is evident in the word "fishermen," which when used by Islanders includes women and children. For a select few, fishing literally equals family.

Art Sivertson in the gas boat, Sivie, 1950.

In the passage of 100 years, the Sivertson family has witnessed and adapted to a parade of changes. Sail- and row-powered Mackinaw boats evolved into gas boats. Cotton and linen nets became nylon. The navigation skills and instincts of fishermen have been augmented by radar and depth-finders. The feeling of being alone on the lake has been muted by the advent of marine radios. Throughout all these changes, the Sivertson family link to the Island remains firm, the rock upon which this book is built.

While Bud's work reflects family and personal roots to Isle Royale, it also chronicles an archetypical story of an immigrant family becoming proud Americans. The family comes to the New World with the hope and belief that it will be the land of opportunity. The family fashions a satisfying existence from nature, adjusts to a new world, and misses the old. The story celebrates "doing," hard work, and entrepreneurship.

The paintings and narratives also tell the story of Bud Sivertson's coming of age, of learning who he is. "Caught Inside the Breakers" illustrates a boy learning to master fear, adrenaline, and his first solo captainship in a storm. The boy learns as much through errors and excesses as through insight. It is a story about a boy's relationship to his father, of trying to fill, not his dad's boots, but his hip waders. The story, however, is not peculiar to Isle Royale. Cloaked in the wondrous setting of commercial fishing on Isle

Royale, it is about universal emotions and experiences of growing up. This invites readers to view their own lives, their own childhoods, in comparison to Bud's.

Aptly named, Isle Royale is a striking place. The fundamental clash of water with land, with its truce—islands and boats, pervades Bud's childhood home. Icy waters envelop the rocky archipelago, generating fogs, "dirty weather" such as squalls, and the bewitching calm summer days. The lake is always an influence, and in Bud's paintings it is always there.

For Island fishermen, the lake is both a giver and taker of life, a challenge and an intrinsic part of their existence. Some, like Bud's uncle Stan Sivertson, candidly admit they are scared of it, despite more than a half century on the lake. While admission of fear is rare, the concern is habitual for wise mariners. For some, this constant wariness is not enough. On occasion, the lake has taken even veteran fishermen. All the fisherman can rely on is himself, his boat, and the exercise of calm, swift judgment.

The archipelago's rocky slopes and studded reefs, with a mix of deep and shallow waters, provide productive fish habitat, especially for lake trout, lake herring, and some whitefish. Island fishermen recognized distinct and localized trout stocks, like "Rock of Ages" trout, mooneyes, black siskiwits, paperfin, and others. Spawned in specific locations and during different times, each trout stock tasted different, and to a degree,

behaved differently. Fishermen were finely tuned to the differences, and knew when and where to fish "salmon trout" and how to avoid "lemon trout," or suckers. But even these "localized" fish stocks move in response to water temperature and clarity, lake currents, and predators. Fishermen had to move their gear regularly to follow the fish.

The diversity of highly desirable fish— trout, herring, and whitefish—distinguished Island fishing from the North and South shores of Lake Superior. On the Island, trout and herring were economic mainstays, with late-fall whitefish a welcome bonus. On the North Shore, herring was "king," and on the South Shore, whitefish was most important. The Island fishermen had wider options: to fish herring, or trout, or both. Also, Island fishermen were removed from mainland opportunities to supplement their incomes, so they became "fishing specialists." On the mainland, jobs in the iron industry, tourism, and lumbering lured away less-than-steadfast fishermen.

The special "tariffs" of Island fishing— extra transportation charges, the relative isolation, and seasonal moves on and off the island—made it less attractive to some. Working on the Island also precluded many mainland winter jobs, as the families did not return to the Minnesota shore until late in November. People were forced to choose, in effect, "to be or not to be" an Island fishermen. The Island was solitary confinement for some, and a siren to others. Those who stayed accepted and worked with its givens.

Fishing is the glue that holds together Island history. For ancient and modern Island-goers, fishing is the constant, a common activity and source of food. Ample traces of fishing have been discovered in the campfires and occupation sites of prehistoric people. Near a historic Island fishery were found notched stone sinkers used to hold a net vertically in the water. At other sites, archeologists have carefully sifted for fish bones, which, when identified, remind us that other fish were present in earlier times. Even "warm-water fish" such as red horse suckers, sturgeon, and pike are found in these ancient Island middens.

Ojibwa fishermen first used gill nets made of woven bark, then quickly adopted the cotton nets of the American and British fur traders. Individual family groups from Grand Portage and Thunder Bay bands visited the Island because of the reliable concentrations of fish as well as caribou and beaver. Traditional seasonal fishing camps sprung up at Grace Harbor, McCargoe Cove, and Rock Harbor. Like the fishermen to follow, Ojibwa fishermen discovered and named favorite grounds, such as Siskiwit Bay, named for a preferred oily trout. On the Island, Ojibwa fishing was basically a subsistence fishery, yet its technology and environmental knowledge became the basis for the first European-American commercial fishery on the lake, operated by the American Fur Company.

Even using small-scale, labor-intensive

technology, the American Fur Company (AFC) had a peculiar problem—it caught too many fish. Siting fisheries around the American side of the lake, the AFC established seven stations on the Island with the main depot at Siskiwit Bay. From 1837 to 1841, the company employed fishing- and Island-wise Ojibwa and métis (Ojibwa-

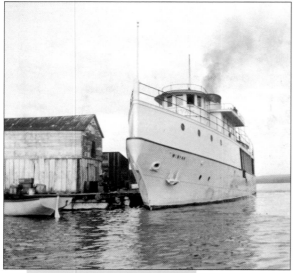

Steamer Winyah *at Booth Dock, Washington Harbor, in the late 1930s.*

French descendants) to do the fishing. Fish were caught in familiar gill nets, then cleaned, salted, and "pickled" in barrels for shipment on schooners to Midwestern markets. Too many fish and too few buyers plagued the enterprise until an economic panic forced the operation to close, and the company became insolvent.

Fishing did not cease after the AFC failure. Instead, smaller companies and independent fishermen continued to fish Island waters seasonally. The growth of local markets in Duluth, Marquette, the Michigan copper district, and lumber towns made fishing profitable. Significant technological changes were also afoot in the second half of the 19th century. Safe, maneuverable, even rowable when necessary, Great Lakes Mackinaw boats became the fishing boats of choice. Railroads linked Lake Superior towns with the larger Midwestern cities of Chicago, Milwaukee, Minneapolis and St. Paul. Refrigerated rail cars could now carry fresh fish and meat to market. But the coming immigrant tide of Scandinavians, cresting between 1880 and the turn of the century, revolutionized fishing on the big lake.

Severin Sivertson was only one of many Norwegians who flocked to Isle Royale. Swedes and Swede-Finns came too, but most fishermen came from the North of Norway. For many, the deep harbors and small islands of Isle Royale reminded them of the fjords in the Old Country. The local dominance of Scandinavian fishermen led to the assumption that to fish well, you "fished Scandinavian." Fishing knowledge from the Old Country was adapted to the new. Hookline fishing technology used on the Atlantic and Baltic was modified to catch lake trout. Scandinavian boat-building knowledge and craftsmanship was grafted onto American ways of making Mackinaw boats and herring skiffs.

While learning new ways of freshwater fish and fishing, immigrants on the Island enjoyed life in an ethnic enclave. It was a refuge where families could measure out the pressures of becoming American. While fishing "Scandinavian," they could proclaim their American pride through the Fourth of July celebration, an event which took on special meaning for them.

The tastes of Scandinavian immigrants across the Midwest also had an effect on fishing. Scandinavian farmers craved herring and bought it frozen in 100-pound gunny sacks. Fresh fish on ice, rather than salted, also became popular. These market preferences created a boom for herring fishermen. Trout fishermen now needed lots of precious ice to keep fresh fish cool, and they needed to ship fish more frequently. Highly-capitalized fish companies with large freight ships and regular schedules became a necessity. For Island and North Shore fishermen, the dominant company was A. Booth Fisheries, which ran the beloved freight-and-passenger ship, the *America*.

Fishing reached its high mark from 1902 to 1928, during the *America* days. Reliable, relatively fast, and even semi-elegant, the *America* was the favorite ship to travel to and from the Island, as well as to haul Island fish. The *America* is important not because it was the first or largest ship, but because for fishermen it is synonymous with a golden era of fishing. During the *America* period, a unique fishing culture flourished for over 100 fishermen and their families living in the sheltered coves

of the archipelago.

During this Golden Age, Isle Royale was the territory of fishermen by action, if not by letter of the law. Fishermen were alone on the Island and customary practice rather than regulation was the norm. For example, fishermen developed a custom through which they allocated each fisherman's fishing grounds for a year. Island fishermen developed a strong sense of who they were from a strong brew of occupational and ethnic pride, Island and harbor-specific identification.

As in fishing cultures elsewhere, Island fisher folk agreed upon many values and held distinct notions of proper behavior. Fervent ideals of independence, self-reliance, and hard work were compromised only when a neighbor was in need. Nature, especially in the form of the lake, was acknowledged to be in control. As in "Spring Arrival," where men had to haul their supplies and skiffs over ice to get to their fisheries, nature's rhythms

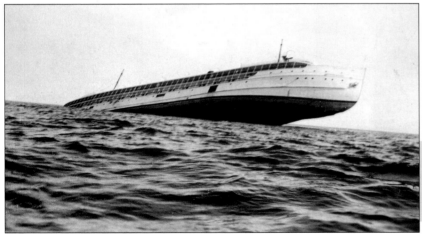

defined their lives. Even the Fourth of July came at a good time, when fishing was slow and fishermen were changing from hook-lines to gill nets. Fishing, and family life in the harbors, was seasonally prescribed.

The meager economic return of fishing intensified fishermen's creativity. They had to find their own modest ways of doing things. They recycled parts of shipwrecks into houses or collected pulpwood sticks as fuel and for building material. Or, after the lamprey devastated fishing, Ed and Ingeborg Holte welded together sculptures from rusty engine parts and fishing equipment to decorate their home interior and its surrounding grounds.

Bud's devotion to documentary realism is evident when he depicts the complexity of fishing. Fishermen have a negative stereotype to overcome, of low-class, drone-like work. But any view that fishing is mindless, even primitive, is more a product of our own primitive knowledge of fishing. Island fishing was not simple or easy. Each day presented new conditions, challenges, and opportunities. Fish behavior changed in response to fluctuating currents, water temperature, air pressure, bottom

The cruise ship George M. Cox *on Rock of Ages Reef, 1933. Currently, some of the wreckage is still visible.*

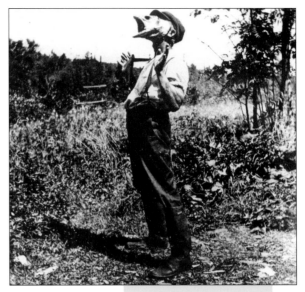

conditions, and seasonal weather patterns. Isle Royale fishermen gained intricate environmental

This humorous image was discovered in a family album from Fisherman's Home, a harbor on the southeast side of Isle Royale.

knowledge, born of the trial-and-error effort of fishing. They received immediate feedback to their hunches when they lifted nets and found fish, no fish, or worst of all, ruined gear. Attuned to weather conditions, Ingeborg Holte could tell me wind direction and speed, and "forecast" the weather by the temperature of her home at Wright Island. Knowledge mixed with experience led to remarkable insight about nature.

The complexity of the task of fishing helped fishermen, like Stan Sivertson, to remain curious, to learn continuously, and thus become better fishermen. Stan was always experimenting with different colored

nets or sharpening his hookline hooks. He was always thinking of new design features to make a better boat. Through conversation

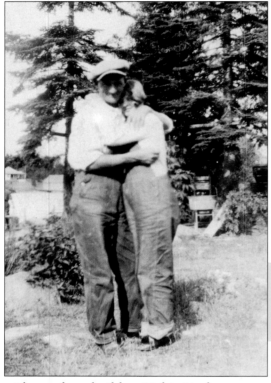

Art and Myrtle Sivertson as young couple on the Island, 1929.

with area boat builders Hokie Lind or Reuben Hill, Stan's ideas would be made manifest in a new gas-boat hull design. Fishing rewarded those who knew the most and could adapt to ever-present changing conditions.

At the heart of Island fishing values is the primacy of women. Women are centers of life, not merely helpmates. Bud is amazed at what Island women had to contend with— including the most enigmatic creatures of all, moose and men. Fisher women are the captains of the home, equally hard workers, and the keepers of the family. And, if there is a hero in this book, it is Bud's grandmother, T'dora. She endures with grace. She bakes bread for the harbor, a giving, humane actor in a life built around water, boats, and fish. She is the presence, the shadow, behind Bud. Bud realizes Grandma, and women generally, provided necessities which made Island fishing whole, which made a way of living from the lake complete.

The actual act of fishing is also obviously a male enterprise. Men took pride in catching fish and providing for their families. Bud portrays a joy and satisfaction of men working together, of instinctively knowing what the other man is going to do. Long, sometimes tedious hours of working together can breed very elemental understandings. As with the Ekmark brothers in "Emergency Repairs," there are magical moments when the work gets done fast, without obvious communication.

Other fishing values are embodied in this work. Born of necessity, simplicity is highly esteemed and inculcated to the point of being a virtue. The "Bachelor's Shack," free of anything extraneous, is a den of rich, direct smells. On the surface about religious instruction, "Bible Class" is also about material simplicity in the home, there being few chairs on which children could sit. Simplicity, more than religious instruction, became the Island gospel. Simplicity allowed versatility in fishing and, if their gear broke, fishermen could mend it. Simplicity and self-reliance were intertwined.

True to fishermen's experience and values, this book contains a fleet of boats. Boats are transportation, work platforms, recreation vehicles, sturdy yet demanding companions, and sources of individual pride and community discussion. "Talking" and observing boats, discussing their biography of ownership and their merits or faults, is part of Island fishermen's way of life. The bond to boats is proverbial and includes the acceptance of a boat's worst and best qualities. Absolutely ideal boats were nonexistent. Instead, boats meant trade-offs. An "ideal" design feature in one sea condition might mean a wet ride in another. But having a boat, even one with extreme liabilities like the "Red Skiff," was imperative. A good boat is better than a bad one, but a marginal one is vastly better than none.

Besides, in the hands of an Island fisherman a boat would be improved upon—or sold, or beached. Boat technology was open to creativity and change. Fishermen might build their own skiffs or, for larger gas boats, tell boat builders what they wanted. Conservative fishermen might stay with "double-enders," innovators with the ever-evolving gas-boat design.

Another hallmark of life on the Island was the directness of contact between fishermen and nature. Like the painting of the fishermen in a squall tied to their buoy line to ride

out rough seas, fishermen lived within the forces of nature. Only a thin line, often of ingenuity, kept them from being blown to disaster by a storm. Even on shore, fishermen erected few boundaries to separate themselves from wild things. Baseball was played, not on a cropped field, but on a hummocky marsh. Or for Ingeborg Holte, even her prized roses ringed by white rocks were eaten by an adventurous beaver. On the Island, nature and human fisheries overlapped.

Fishing gear had to work and it had to

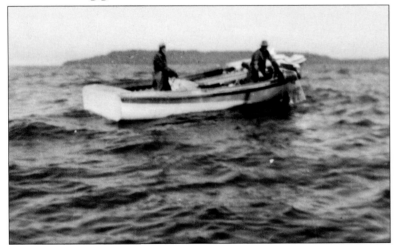

Einar and Carl Ekmark in their gas boat, Doris, *that was damaged in a storm and nearly sank (see "Emergency Repairs," on page 68).*

bring the fisherman safely home. Island fishing technology was labor-intensive and small in scale. It never insulated work or home life from the environment to the degree that fishermen could become

arrogant, or casual, about that relationship. This personable technology worked to prevent environmental abuse.

Another element retarding abuse of the environment was conceptually based. Experience taught Island fishermen that the Island, by nature, had finite limits. They knew superlative fishing grounds were limited, fish numbers needed to be protected, and excellent sites for fisheries were scarce. With its pervasive limitations, Island life taught fishermen they must steward their resources carefully. Because of this "lesson" and modest technology, Island fishermen did not overfish. Instead they bequeathed to future generations an unequalled genetic reservoir of lake trout. Nowhere else in the Great Lakes are lake trout doing as well. Around Isle Royale, native (versus hatchery) fish are the rule rather than the exception.

Island fishing life was also defined by the seasonal movement to and from the Island. Winter on the mainland allowed for binges, packing in activities that could not be done on the Island. But as on the Island, independent thought and action prevailed. While one fisherman might be drinking, fishing partners Conrad Scotland and Andrew Anderson sat and played the Duluth Stock Exchange. Despite their woollies and bachelor-fisherman demeanor, they mingled

with Duluth's finest at the Exchange.

During the fishing season, extreme isolation prevailed. Life was framed by moments of dramatic connection to the mainland, when the mail-and-supply boat came. The contrast between mainland and Island made the choice of where to live paramount. Each annual move to and from the Island only made the fisher folks more aware of the specialness of Island life.

In some respects Island life was a "throwback," a backwater in a rapidly changing society. It was a verbal society where talk and stories pervaded. Stories of unusual Island events were never superseded by print or electronic media. News came from deckhands on boats, supplemented by the periodic arrival of newspapers. Telephones were never a threat, and radio reception was not the greatest.

Fishermen were self-reliant for entertainment. For example, each member of the Holgar Johnson family played a musical instrument and contributed to a family "orchestra." For the more isolated fishermen, wild animals became welcome acquaintances. The Holtes on Wright Island, for example, named a moose "the Tourist" because he showed up in their midst on Memorial Day and disappeared on Labor Day. An emboldened mink that regularly watched Ed Holte clean fish was dubbed "the Inspector."

A final distinguishing characteristic of Island life was fishermen's devotion to the place they lived. Their rootedness was not simply an affection for a particular piece of

property, or even for a home. Rather they were attached to human relationships intertwined with a remarkable locale, often their special harbor. This affection was deep and barely on the edge of consciousness. This sense of connection, of "always having the Island," only intensified when conservationists began efforts to establish Isle Royale as a National Park.

Bud was born in 1930 on the eve of great change on the Island. A year after his birth, the U.S. Congress created Isle

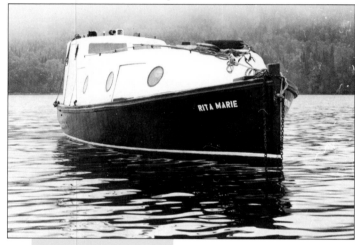

The Rita Marie, 1942, was first of a series of Sivertson Brothers' boats, run by Howard's father Art and uncle Stan, used to haul mail and freight.

Royale National Park in concept. Before his tenth birthday, National Park Service rangers were a periodic sight. Until that time, by living on the other side of the "moat" of Lake Superior, Isle Royale

fishermen had been shielded by distance and isolation from most incursions by the wider society. The coming of the Michigan Department of Conservation game and fire wardens and later, Park Service rangers, broke down customary traditions of local self-control. State and then federal restrictions, meant to foster recreation and wilderness appreciation, clashed with Island customs, values, and the issue of continued use.

The assumptions and ideals of conservationists from the lower peninsula of Michigan and Washington, D.C., differed from those of the fishermen. To the wilderness planners, the concept of preserving a valuable local culture with rich ties to the Island was at that time beyond the realm of acceptable ideas. Fishermen's moral rights of lengthy land tenure and good stewardship were not enough to budge the assumption that humans and pristine lands fundamentally do not mix. Fishermen, and summer people, had to go.

Fishermen were never really a thorny obstacle for the creation of the park as few owned their property. Nor were they wealthy enough to have much political clout. The basic deal struck was that, in general, fishermen and summer people, even those without title to their land, could stay at their Island homes through their lifetimes, then that property was to revert back to "wilderness." The actual policies were enforced in different ways, at different times, by the multiple agencies involved.

Island families were prohibited from gathering berries, from using local materials for needed repairs. Fishing regulations were tightened and license fees raised. Some buildings were burned when no longer in active use. In the eyes of the fishermen, the effect was to make them feel unwanted, extraneous on the Island where they had been born and raised. It became harder to involve younger family members in fishing operations that had no future. With the concurrent devastation by the lamprey of the trout populations, gradually the fishermen found their options closed. Many found it impossible to continue fishing as they had before.

Bud grew up when the weight of these decisions was settling in. Eventually his family would be exiled. And the fundamental rationale for this eviction made little sense to him and others. His quandary was this: how can the Island be a true wilderness when at Washington Harbor he smelled the aroma of his Grandma making bread? What is the value of a family having a 100-year attachment to a place? How do we discount the fact that over 400 buildings dotted Isle Royale at the time the park was created? How can you reconcile the past of the Island, replete with peoples for thousands of years, with a desire for a wild landscape free of humans? Can the removal of fishermen be simply explained as an unfortunate but necessary deed for the greater good? How do humans and Isle Royale mix?

Bud and others were caught between the

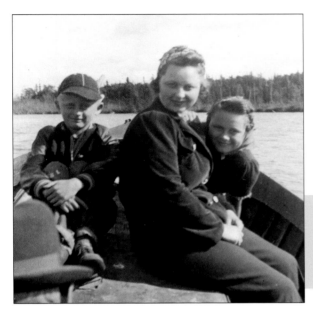

Howard, his mother Myrtle, and sister Betty in small boat, with Island in the background, ca. 1940.

collision of two cherished American values. In one dream, an immigrant family becomes American by struggling to win a living harvesting wild resources. In another dream, evolving in the 20th century, grew a fervent belief in "the best idea America ever had" —the National Parks. Ironically, a negative stereotype of the "pioneer dream"—that pioneers were inherent despoilers of nature—was antithetical to the values of parkland preservation. On Isle Royale, the dream of preserving Nature in an idealized form gained overwhelming supremacy.

In effect, the decision on Isle Royale was to manufacture wilderness, certainly an oxymoron. And for what? As a country, do we value the recreational opportunities of urban dwellers more than a local culture which produces food for others and stewards its resources? Further, as environmentalists,

are we not looking for role models of people living sensibly and intimately in pristine lands? Or should we throw the baby—of sensible traditional stewardship—out with the bath water of commercial interests unchecked? Should we adopt wilderness legislation that presumes humans are inherent despoilers of nature and thus must be removed from wild lands?

Manufacturing wilderness is one thing. Forgetting that a choice was made is even more heinous. Overlooked are the removal and sacrifices of fishing families—of Buddy and his fellow "Island brats." On Isle Royale, making wilderness means the purposeful erasing of people's place on the Island.

Bud Sivertson's paintings and text challenge unexamined assumptions about wilderness and Isle Royale. His book, though mostly about the past, counters the accepted formula of wilderness parks, namely, that they become national shrines defined by dead culture and live nature. It is also important to look beyond the Island and fishermen, for these notions and actions apply elsewhere.

Sivertson gently reminds us we never learned what the fishermen could teach us about the lake and fish. The environmental knowledge and experience of "the folk" is often discredited or trivialized. Bud has watched Isle Royale become emptied, to be fashioned into an artificial landscape.

Ultimately, the issue becomes: what is the authentic Isle Royale? Is there not an alternate way to appreciate wild things suggested in *Once Upon An Isle*? Sivertson challenges us to envision a place where people and nature are not inherently estranged, where "schools of kids" change directions like the fish their fathers pursue.

Through this work Bud has momentarily repeopled the Island. He forcefully reminds us that Isle Royale means family, fishermen, and knowledge of its resources borne from hard work and care. He alerts us all is not as it first appears, like the cookstove being carried down to the dock for the ride back to the North Shore. Portraying the essential frugality of fishing families and seasonality of fishing life, the cookstove becomes a lasting image of the fishing hearth being carried to the mainland. Meant to imply the closure of one season and the continuity with the next, it becomes inverted, with the heat and vitality of family life quickly cooling as it is carried from the Island.

Still, Bud remembers the time when he always had the Island.

Further Resources

Howard Sivertson's Artwork:

For information on Howard Sivertson's original paintings or print series:
Sivertson Gallery
Broadway & Wisconsin
Grand Marais, Minnesota 55604
(tel: 218-387-2491)
Open May-December

Sivertson Gallery
Lutsen Mountain Ski Area
Lutsen, Minnesota 55612
(tel: 218-663-7842)
Open year-round

Wisconsin Folk Museum
100 South 2nd Street
Mount Horeb, Wisconsin 53572
(tel: 800-736-9189)
Open May-Labor Day
Toll-free telephone line, year-round

Grand Marais Art Colony
Box 626
Grand Marais, Minnesota 55604
(tel: 218-387-2737)
Sponsors art and writing workshops, May-November, with Sivertson and other prominent area artists; write or call for catalogue.

Isle Royale National Park:

Isle Royale National Park (headquarters)
Houghton, Michigan 49931-1895
(tel: 906-482-0984)
Write or call for information on transportation to island, lodging, camping, group camping, and general visitor information packet

Isle Royale Natural History Association
c/o Isle Royale National Park
87 North Ripley
Houghton, Michigan 49931-1895
(tel: 906-482-7860)
Publications on Isle Royale natural history and cultural heritage

Grand Portage/Isle Royale Transportation Company
1507 North 1st
Superior, Wisconsin 54880
(tel: 715-392-2100)
Scheduled excursion boats from Grand Portage, Minnesota

Suggested readings on Isle Royale and Lake Superior fishing heritage:

Charles Waters. *The Superior North Shore*. Minneapolis: University of Minnesota Press, 1987. Chapters on Lake Superior commercial fishing and on Isle Royale.

Matti Kaups. "Norwegian Immigrants and the Development of Commercial Fisheries Along the North Shore of Lake Superior, 1870-1895." In *Norwegian Influences on the Upper Midwest*, edited by Harald Naess, pp. 21-34. Duluth: University of Minnesota–Duluth, 1976).

Dorothy Simonson. *A Diary of an Isle Royale School Teacher*. Houghton: Isle Royale Natural History Association, 1992. Diary of a school year at Chippewa Harbor with one fishing family.

Tim Cochrane, ed. *Borealis: An Isle Royale Potpourri*. Houghton: Isle Royale Natural History Association, 1992. Collection of historical essays about Island life.

Willis H. Raff. *Pioneers in the Wilderness*. Grand Marais, Minnesota: Cook County Historical Society, 1981. History of North Shore pioneer life.